The Suitcase
Stories

Refugee children
reclaim their identities

Glynis Clacherty
with the Suitcase Storytellers and Diane Welvering

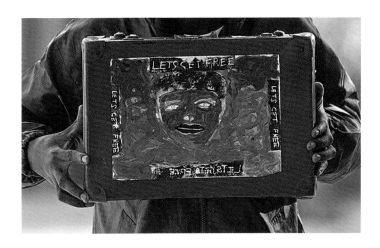

"We made these suitcases for some of the people out there. There are rich people out there who live large. They don't know how poor people, like refugees, live. They don't know. They got to know."

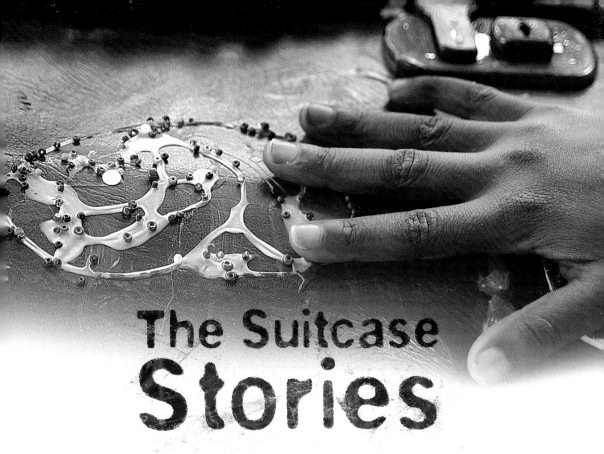

The Suitcase Stories

Refugee children
reclaim their identities

Glynis Clacherty

with the Suitcase Storytellers and Diane Welvering

DOUBLE
STOREY
a juta company

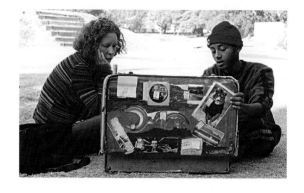

"I am going to Namibia to look for my father. I want you to keep my suitcase and give it to my sister in Ethiopia if I do not come back."

Published 2006

Reprinted 2008

by Double Storey Books,

a division of Juta & Co. Ltd,

Mercury Crescent, Wetton, Cape Town

Written by Glynis Clacherty and the Suitcase Children

Artwork by the Suitcase Children with direction from Diane Welvering

Photographs by Suzy Bernstein

Editing by Gwen Hewett

Design and layout by Jenny Young

Printing by CTP Book Printers, Parow, Cape Town

W/T No. 45413

Information on refugees written by University of the Witwatersrand Forced Migration Project

© Glynis Clacherty and the Suitcase Children 2006

ISBN-10: 1 919930 99 X

ISBN-13: 978 1 919930 99 2

The Suitcase Project

This book was produced as part of the Suitcase Project, a psychosocial support through art therapy project initiated by Glynis Clacherty in 2001 in Johannesburg, South Africa.

During 2003, Annurita Bains co-facilitated the group with Glynis.

During 2002, Diane Welvering joined the project as an art teacher and, together with Glynis, developed the work that is presented in this book. Jessie Kgomongoe worked alongside us for two years.

The group meets at Barnato Park High School in Hillbrow which has made its facilities available to us since 2003. The project was partly funded by the United Nations High Commission for Refugees (UNHCR) during 2003 and 2004, through the Jesuit Refugee Service (JRS).

From 2006, the project will be run under the auspices of the Refugee Ministries Centre, a refugee programme run by the Anglican, Methodist and Lutheran churches in inner city Johannesburg. Children are referred into the group on an annual basis by the Refugee Ministries advice centre. Funding is provided through the UNHCR for an interim period, but more substantial funding is being sought. If you want to know more about the project contact glynis@clacherty.co.za

Glynis Clacherty is a researcher who specialises in participatory work with children. She has spent the last ten years working with children all over southern Africa on issues such as HIV/AIDS, child work, violence against children, poverty and migration. Much of this work has allowed children's voices to be heard in the creation of new policy and laws. She started the Suitcase Project, a psychosocial support through art project, in 2001 with refugee children in Hillbrow. This is where she met the children whose stories are told in this book.

How this book was written

As part of the therapeutic work in the Suitcase Project children told me their stories, some over a period of three years. This activity was completely voluntary and children could choose how much of their story to tell, if they wanted it taped and even if they wanted to tell it at all. I transcribed those stories that had been taped and edited them for sequence and readability alone. I have tried to represent what the children said exactly as they said it, keeping the form of the spoken word. The children all looked closely at their stories once they had been written, and we agreed on which parts could be published and what they did not want included in the book and what needed to be changed to keep their confidentiality. None of the children want to be labelled as refugees in their present lives, so they have chosen to remain anonymous. The names they chose to replace their own all have significance for them; they are names of lost parents or special friends from their home countries.

As I have worked with these stories I have been struck by the sadness, the loss, the displacement that the children have experienced but also overwhelmingly by their resilience, their ability to make a plan and often to see the funny side of what is happening to them. These stories have taught me that children are not merely victims of their circumstances but survivors.

Glynis Clacherty

"This suitcase is a good memory. I want to keep it for my children so they will know what I have done and where I have been with this suitcase, my life."

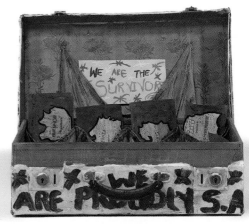

Where the children come from

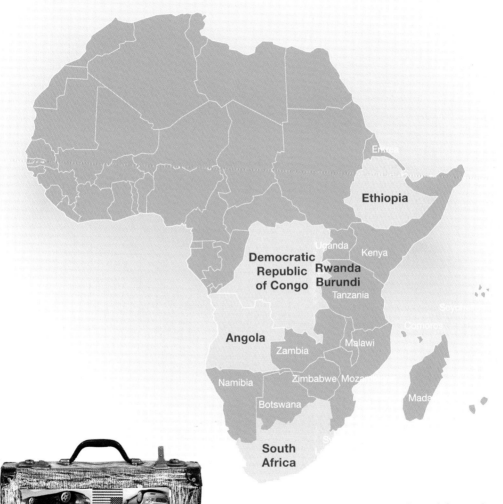

Eritrea

Ethiopia

Uganda Kenya

Democratic
Republic Rwanda
of Congo Burundi

Tanzania

Seychelles

Comoros

Angola

Zambia

Malawi

Namibia

Zimbabwe Moza

Madag

Botswana

South
Africa

"I am going to always take this suit-
case with me. I want to go to Australia,
and I will take this suitcase for my
interview because it tells my history."

Contents

"I remember when I left my country, there were many people waiting at the bus and there was a pile of suitcases. My suitcase reminds me of that time when we were all pushing to get on the bus, and we were afraid, and we wanted to get away because of the war."

"I have decorated my suitcase because I love it! I will always keep it."

Please help me make a book to tell my story

This story begins with a young Ethiopian girl called Zenash, who was 14 years old when I met her. She had long black hair, brown skin like toffee, and an angry energy that made her stand out in the room full of children that waited for me on that Saturday morning in March 2001.

I had been commissioned to collect stories about xenophobia for use in an educational television series, and had telephoned the Johannesburg office of the Jesuit Refugee Service to ask if I could run a workshop with some refugee children, to record their experiences of life in South Africa. The children who waited for me at the JRS office in inner city Johannesburg were all "separated or unaccompanied children" – children under 18 who had become orphaned or separated from their parents, either before they left their countries of origin or on the journey to South Africa.

Zenash was one of them. As the children painted pictures of their lives in Johannesburg and the journeys they had taken to get here, she told me her story.

I was at school in Eritrea, in a boarding school. My parents live inside Ethiopia. We live in very nice house. Once we went to Egypt, and I have been to Italy when I was very small.

During the holidays, I went home to visit my parents. I was 12. I found that they are not at home. I ask a friend where my parents are. She said she does not know – I must go back to school. Then I went back to school. The teacher said I am not allowed to study at that school any more. I went to Kenya border. From there I ask people to call Wanya my friend. I told her I don't know where my parents are. She told me to go back to school. I saw one of the girls at the border, I knew her from school. She asked me to come with her to Nairobi.

We stayed in Nairobi for one week. Then we went to Tanzania, then to Dar es Salaam. After to Mozambique. Tanzania was so bad. In jail they give us bad food. I was crying, because everything was

different and new at the same time. My friend, she was sick in jail with malaria. I was not feeling good. Then to Mozambique. People from Mozambique were not nice – terrible. After, Swaziland for two days.

In South Africa border the police catch us. I was running – the police shoot two times in the air. I was running. One boy pay police some amount – I don't know how much.

Then I come to Johannesburg. I was living in a flat. In that place I was living with two girls from my country. One of the girls, she leave me there. She was going to Cape Town on some business and she did not come back home, and she phone other girl and she tell her she is leaving, and I was crying because I did not know what to do, and one man said I must give him some money for rent. But I did not know how much it was. I was in the street and I was crying, and someone asked, "Why are you crying?" I told him what is the

problem. He said I must come to Ponte City, and there is a mother in that place who will take me to the place [the JRS] where there are people from other countries. And it was there I meet Miriam. I started living with Miriam's family in 1999.

If I have one wish, I wish to finish school and go back my country to find my parents; my family. My family don't know where I am, or maybe they think I died. And I don't know where they are. Maybe they think I am dead.

As I left that afternoon, Zenash came up to me and said, "Help me make a book about my story. People need to know why we are here. We don't choose to come here. They need to know."

All week I thought about Zenash and her story. My own daughter was also 14 years old and also had long black hair. All week I thought about what she would do if she

came home one day and we had been taken away. Would she be able to make a journey like the one Zenash had made? What would the impact of these extraordinary events be on her? How would I feel as a mother if I did not know where she was? How would she feel if she did not know what had happened to me?

By the end of the week I had made a decision – to see the group again and to help Zenash tell her story, just as she had asked.

At first we met informally, partly because I did not really know what else to do with the group. I took them to Zoo Lake for a picnic; we went swimming together. Through this informal contact I got to know the other children in the group.

There was Acacio from Angola, a tall rangy boy who was growing out of his clothes, and who was deeply depressed and withdrawn. There was sweet Paul from Rwanda, who spoke almost no English but grinned constantly with a wide, gentle grin. There was Pasco from the Democratic Republic of Congo (DRC), who looked like a street thug but who played gently with the younger children. Jean, Brian and Winnie also came from the DRC, and they brought along their little sister Ann, who wanted everyone's attention.

There was Jenny with her little baby of eight months, and her sister Francoise, who constantly and cruelly teased the other children in the group. There was a group of three small children from Angola, aged between three and six, who lived with their nine-year-old sister alone in a garage at the back of a house in Bez Valley. Then there were the three sisters, Esther, Isabelle and Beatrice, who were eight, nine and ten years old, who did not know where their parents were. John, CJ and Ada from Burundi lived with their mom, who was also an informal foster mother for some of the other children. Most of the group lived in two run-down flats owned by JRS in Berea.

All of the children had been displaced by war. All had experienced the loss of leaving familiar houses and friends and much-loved grandparents. Many had also experienced terror – some had seen their parents killed, others had been separated from their parents while crossing a border at night, and did not know where they were, though all said they thought they were alive.

Refugees in South Africa

South Africa has been a country of immigration for hundreds of years, and the country's mines and farms have relied on migrant labour from all over southern Africa. After a long history of persecuting the majority of its citizens and sending exiles throughout the world, the end of apartheid has made South Africa an attractive destination for significant numbers of refugees and asylum seekers from conflict-ridden countries across the continent.

There are presently almost 150 000 refugees and asylum seekers in South Africa. Though this number is small compared to the camps in Kenya, Tanzania, Uganda and elsewhere in Africa, many suspect that the true number of refugees in South Africa is much higher. The largest number, approximately 30 000, are from the DRC, with significant groups from Somalia, Angola, Burundi, Ethiopia and Eritrea, as well as growing numbers of Zimbabweans.

The South African government, in collaboration with the UNHCR and other bodies, is helping to return Angolan and Rwandan refugees. Many of these are reluctant to leave, however, and are therefore likely to join the hundreds of thousands of other undocumented migrants in the country.

Unlike most countries on the continent, South Africa does not maintain refugee camps and refugees get little direct assistance. Rather, the country has adopted a rights-based approach, which formally allows refugees the right to work, move freely within the country and access social services such as education and health care. In practice, however, there are significant problems in accessing these rights. Many would-be asylum seekers are refused access to government offices if they cannot pay bribes. Others wait years to be granted formal refugee status, and then still face difficulties in acquiring identity documents and accessing services. Hostility from the police, government, service providers, and South African citizens makes life difficult, and some refugees have even been deported by an overzealous and corrupt immigration control system. The government has undertaken to reform this system, but change is slow in coming.

Their present lives were also difficult. Many of the group did not have proper papers, and spent their lives dodging the ever-present police who sought out illegal immigrants in the streets of Hillbrow. Three of the boys had been arrested for not having papers. At least half of the children at this stage did not speak English well, and struggled to communicate with the others. In addition, food at home was limited and often not enough for teenagers who were growing. Most of them also experienced some kind of xenophobia in their everyday lives, either at school or on the streets.

I also noticed that the children were ambivalent about their identity as refugees. I invited a friend who worked with children to meet the group. When the children introduced themselves to this stranger, none of them said they were refugees; none claimed their home countries. They all said, "I am from Hillbrow" or "I am South African". In their attempt to integrate into South African society, the children had

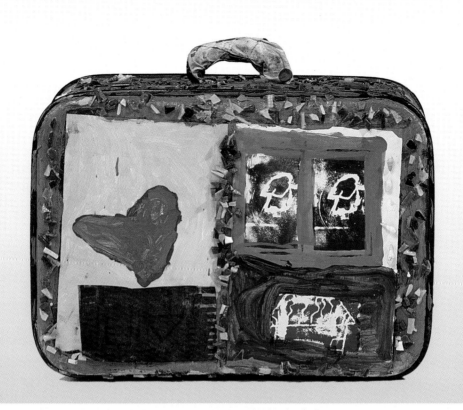
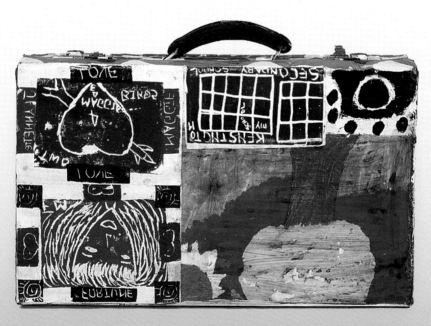

begun to deny their own identities. Only those who were known and trusted could know they were refugees and where they came from – otherwise they were "from Hillbrow".

It soon became clear that outings and games were not enough; I needed to do more. But the children were very sceptical about anything that looked like "healing". When we discussed what kinds of activities we could do together, they were quick to inform me that they did not want to tell stories about past difficult experiences. They resisted any sort of "feeling expression" game, and told stories of negative counselling experiences in the past. One girl summed up her experience of previous counselling:

It didn't help me. She [the psychologist] just wanted me to cry about it. I got bored so I did, and then she [the psychologist] felt better.

An approach that would help the children deal with the psychological effects of their difficulties had to be found, but clearly it had to be something different from the conventional counselling model. I also needed to keep my promise to Zenash, and allow her to tell her story.

At this stage, Diane Welvering, an art teacher, joined the project. She used a creative mixed-media approach, where the children were given many different kinds of techniques and materials but were allowed to decide how they would use them. This seemed to be the ideal approach – we could have fun with art materials, which provided the emotional distance the children needed so they could tell their stories in a safe way.

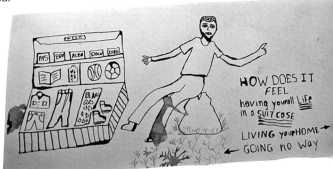

Suitcases!

Then we had the idea of working with suitcases. A suitcase is about a journey; all the children had taken journeys. A suitcase also has a face that is open to everyone to see, and a hidden space inside that we can choose to expose or not. Would suitcases help some of the children to reclaim the memories, both difficult and happy, that they were now choosing to hide? We searched second-hand shops around Johannesburg and Pretoria for suitcases. All the suitcases had been on journeys too, so perhaps the children would relate to them.

Each child chose a suitcase, and then they began to tell the story of their present lives through mixed-media artwork on the outside of the suitcase. Once

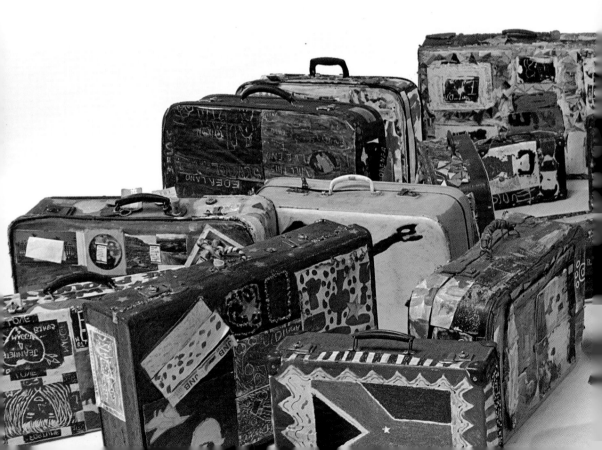

the children felt their suitcases were finished outside, they began working on the insides. The insides of the suitcases were about memories of their pasts.

The artwork was used as a focus for informal storytelling. Sometimes in small groups, sometimes alone, children would bring a piece of artwork to me as I sat under the tree in the school quad where we met and tell the story behind it. They were always given the choice to do this. They were never asked to tell more than the story they had volunteered. Details were not probed, and if a child chose to stop the story, this was accepted. The artwork was always the focus of the story-telling, and this created some measure of emotional distance.

This book is a collection of those stories ...

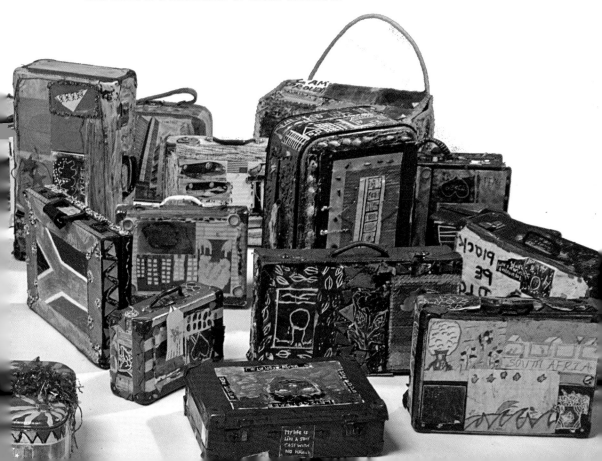

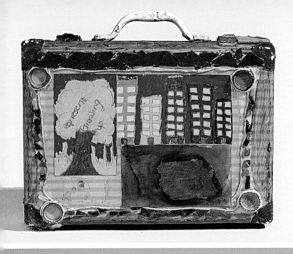
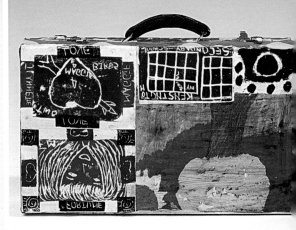
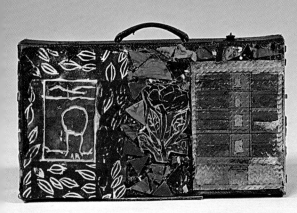
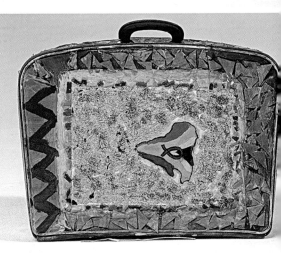
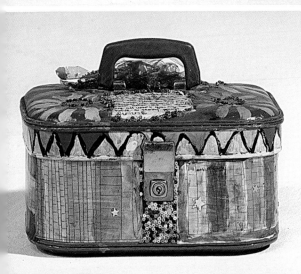
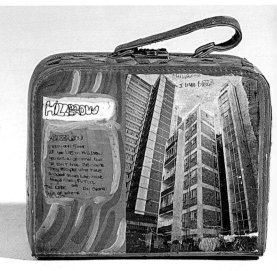

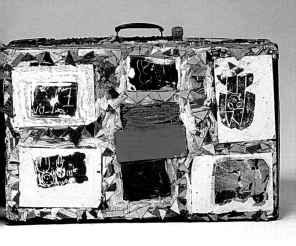
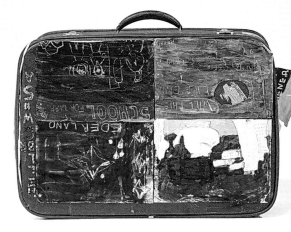
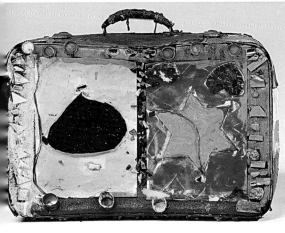
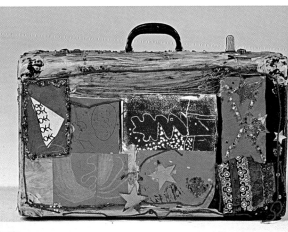
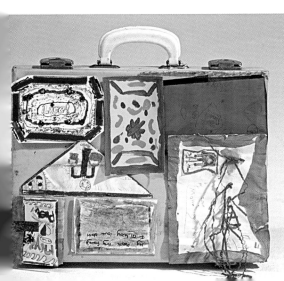
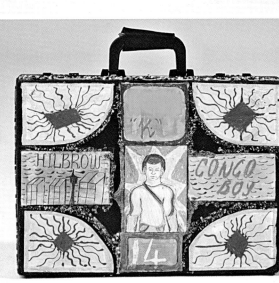

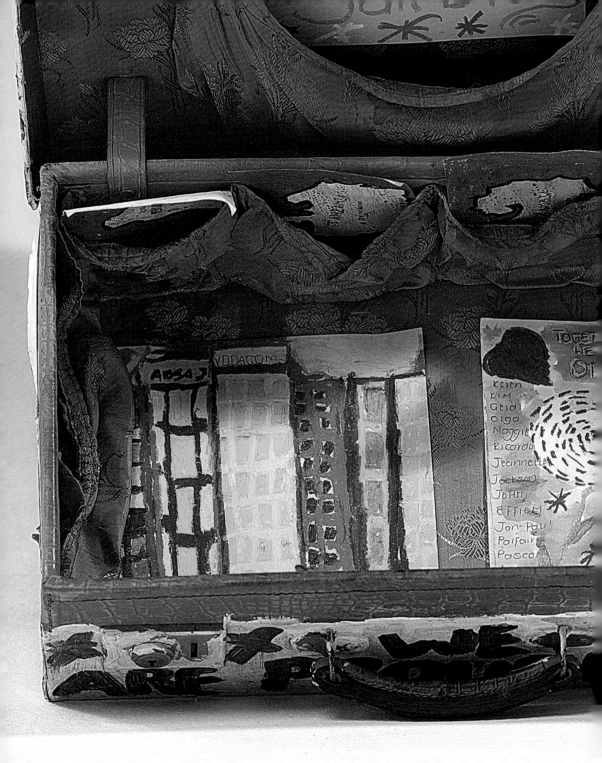

" Open up
these suitcases,
look inside,
and find out
what refugees'
lives are like."

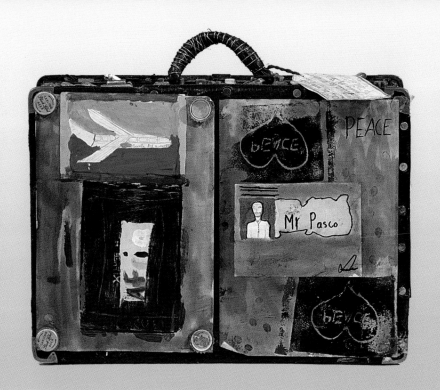
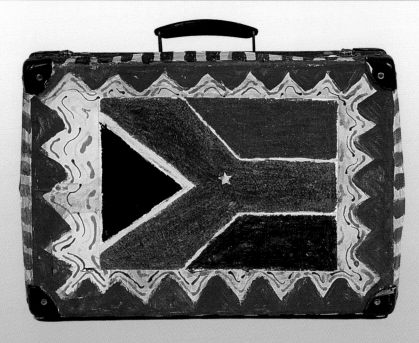

Aggie's suitcase and Pasco's suitcase

Aggie and Pasco are brother and sister. They were born in the DRC but left many years ago to live in Zambia. They have been in Johannesburg since 1999. They joined the Suitcase Project when they were 17 and 15 years old.

Pasco's peace tree

Pasco chose to work on an old battered briefcase with a code. No one was allowed to know the code, and in this way he kept the inside a secret. When we sat down to talk about what he had made, he put on a great show of turning away from us and unlocking the suitcase, to much banter from the other boys. He described what he had drawn with a lyrical touch that belied the tough exterior he had created to protect himself.

This tree in my suitcase, I call it the peace tree. It is for peace and love. At my country I used every time to stand under a tree. I also thought about a tree that is at my home. It means a lot to me. It was a very big tree. I used to stand under that tree. It was a mango tree.

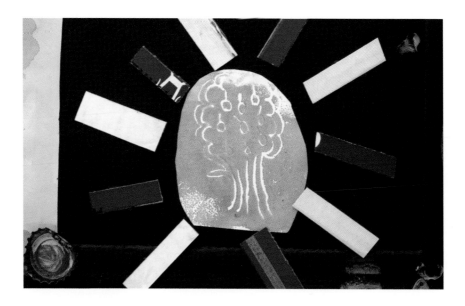

I would sit there with my sister. Then we can talk. It was close to our house, and when it was hot we would sit there nearly the whole night and talk under that tree. I made a special seat to sit in the tree, and I would sit in the tree and think. I was seven or ten, I think. That tree is a blessing on me. I think about that tree a lot, so I put it in my suitcase so I could take it with me wherever I go.

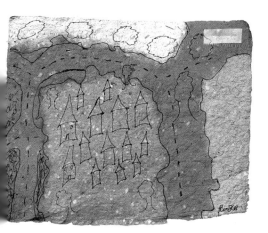

I lost my house where I used to live as a family, and now I am not living as a family. I liked the gathering in this house as a family, because we gather and share what we have together – in mind, soul and in body. But now we cannot share. I lost the house. I cannot say I'll bring it back the same. I might replace it someday in the future, but it won't be the same as this. When my dream comes true and I finally make it, there will be a lot of trees in my house!

Inside my suitcase I have shown a place where we used to walk to when it was hot. It was about five miles from my house. I was about five or six years old, and we used to swim there. This takes me back to rural areas – you can see mountains, trees, birds, different colours. This is the road I passed by on my way to school. There was no pavement; there was a forest.

This is a jacket I remember. I had it when I was very small. They bought it for me – the pastor at the church bought it – that is why I liked it. I wore it to church. It was back home in DRC. I also got a Bible. I read and I learned something. These are girls – they used to be in the choir. We sang a lot of songs, French songs. When I was this age, I was always dreaming about being a soccer player.

A long time ago, I used to go to school wearing bare feet. Every time we go to school, no shoes; I entered this country, now I'm getting shoes. At DRC we had to walk; here we get a bus, a taxi.

I put an African sun on the outside of my suitcase because the bus that brought me here from Congo, it had a picture like this on it.

This is the document I want to have

Thinking about it as I write this, I realise that the choice of a suitcase with a lock fits for Pasco. Apart from the small, beautiful insights into his childhood, and some information about his life in Johannesburg now, he has told us very little about his life story. I know from Aggie, his sister, that his mother died when he was very young, and that he left the DRC and went to Zambia to live with the family of his father's second wife. They came to South Africa with an older brother, who has since married a South African who will have nothing to do with the two of them. So they survive by living with kind people, and moving when the kindness runs out.

In the same way as Pasco locks away his past from all of us, he also locks himself away behind a tough exterior. He wears his pants low on his hips, a fake gold chain and, until they were broken, a pair of large sunglasses. This is partly a strategy for surviving in Hillbrow, but also a role to hide behind. As Aggie tells her story, I realise that she and Pasco have been tolerated as outsiders all their lives, having no one they can trust with the truth. Pasco expresses some of this "outsider" status when he talks about his wish for documents.

Then I drew a picture of myself on a document. It is the document I want to have. It is the permit from Home Affairs. It is my refugee status permit. But I do not have it. I have a problem with papers. I cannot renew my papers.

I am always going to Home Affairs, and every time I go they tell me something different. Once they said they cannot give me papers; another time they said I must come with my teacher. I am going around without papers. I worry all the time that they will arrest me. I use my student card

31

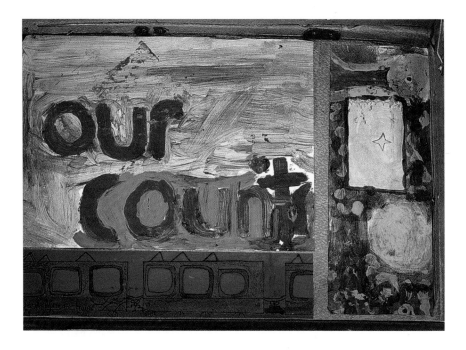

to show them, and usually that is okay. But the police ... we are scared of these people, so every time you go around the corner you check the coast – if there is any blue boys there in those cars. Once, when we were in the street, there is a police car there and another police car, and everyone is running. So us, when we pass by, they left us to pass, and then we just see a gun and we hear it *kkkkk* behind us. There were four of us, and they cock the gun like we are thieves, like we kill someone or are thieves. Hey, it was not okay.

They take CJ, like rough. Put him on the car, stuff like that, you know, and when we try to say we have papers, they say we should respect them as they are guiding the country. It is humiliating, because when they grab you from the belt, giving you a "wedgy" and they hold you up, you can't do anything. It makes you feel very bad, like you are nothing.

Then you have also to worry about the tsotsis. They rob you and take your money, phone, clothes even. The only way for survival here is to look like you are a tsotsi. You have to walk like them, dress like them. When you see them following you, you just turn and say, "Same job, same job." Then they leave you. You have to look like one of them to survive.

Now I live at this flat. I live mixed, we share the flat. Somebody rents the flat, we put rent together. Me, as a student, I tell them sometimes I don't have rent, and they understand. They are mixed. Some are from Venda, some are Pedis – it is a diversity place. They don't worry I am a foreigner. We communicate quite nice. I am staying in my own little room there. I don't have TV or radio, just a few stuff that's mine. I made posters, they call it nice. The view from my room, it looks so nice at night – I see lights, different flats.

I like in my room, I feel comfortable and more clever in my room. Because when I am there, anything I can ask myself I will be able to answer. That is where we gather, in my room. This is where the guys

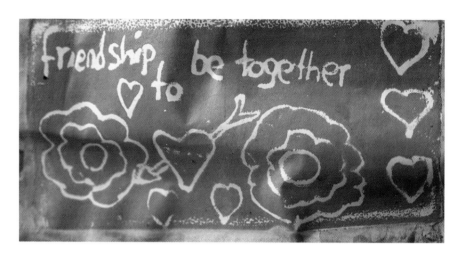

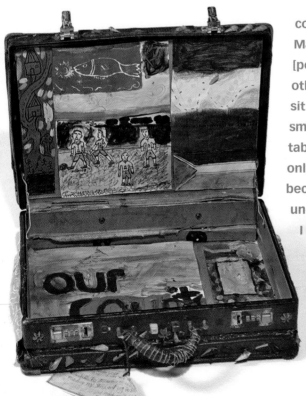

come together: CJ, Paul and Roberto. Maybe we talk and we cook pap [porridge] and soup. There is no other recipe, just pap and soup. We sit in the room, we laugh. We got a small stereo. Someone sits on the table, some sit on the bed – there is only three chairs. I like these guys because I grew with these guys. I understand – when they are angry I have to act this way; when they are happy, this way. But with other persons, you don't know what they can be able to do. I love these boys of mine.

When I am with my friends, topics just come up. He comes

up with his topic, Roberto comes up with his topic, and we try to answer it. They like my room because, first of all, there is no parent there, there are no grown-ups. And they like my room because it is nice with the posters. After church on Sundays we have the pap and soup – soul food.

We all go to the church in suburbs. They fetch us every Sunday. People there, they welcome us, they love us. They treat us like we are their sons, brothers; like we are part of their families. But we are not. We don't have a problem with them, they don't have problem with us. We are one.

This is the Hillbrow Street. The one thing I don't understand is, Hillbrow is this side, but Hillbrow Street is in Yeoville! I often think about this. What happens if you are lost? You will think you are in Hillbrow, but you are in Yeoville!

Mother's Kikwembe cloth

Aggie joined the group a long time after her brother. When I brought her a suitcase, she pointed out in her quiet way the old sticker on the suitcase that says, "Savoy Hotel, Ndola". "I lived in Zambia once, that is where Ndola is," she says. "I think this suitcase was meant for me." She carefully paints around the sticker as she paints her suitcase yellow. She decorates the outside with gold stars and red string. Inside are many small pencil drawings of intimate household objects, such as a pot and a hoe, and a woman carrying water. One of the drawings is carefully executed with great detail. It is a small drawing of a woman.

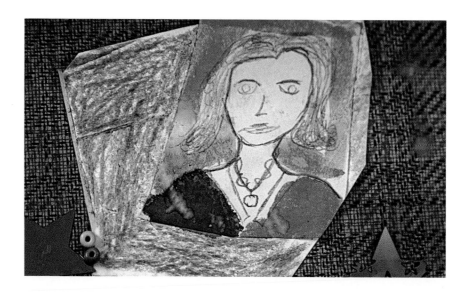

This is a woman like my mother. It is my mother. She passed away when I was nine years old. Pasco was so small; I think about six years old. We lived in the village in DRC.

When I was young, I liked to go with my mother to the fields. Sometimes, when there was too much sun, I would go and sit on

the cloth in the shade – her Kikwembe cloth. She was working and I would watch her work.

This is the hoe she used. She would put me there under the tree and I would play. She would be cooking these mealies in the pot.

It was like a small farm with a small river over there. If I did not go with my mother, I used to cry to my father, "Take me to the river!" I sat at the river with my father until I saw the fish. He used to sometimes take my little brother Pasco, too.

But mostly, I loved to go to the fields with my mother.

This apple tree – my mother used to take me when I was young to see my grandmother.

If I was sick, my grandmother would give me herbs. She knew about leaves for medicine. This tree grew in her garden.

There is a lot about our life in the village in DRC inside my suitcase. Here are the pots for boiling water. We used to take the pots to fetch water. My mother would cook mealies in the pot. We would all help to get water and wood for the fire. The mealies came from her farm.

My mother used to plant and then it would grow, and she would go every day to see if it was ready. I did not always go with her. My mother would go the other side, to the fields, and she would just walk and she always came back. But now …

She died, and my father married another wife called Priska. So I grow with her, from nine years old I grew up with her. I used to call

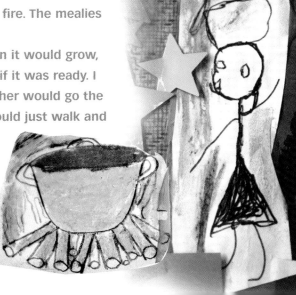

her mother. We stayed there with her. She came from Zambia. She was nice.

We were living, all of us, with Priska and other children – my father had many children. But then the mother Priska died too, from TB, and my father he decided to take us to Zambia, to her family. So he took us from Congo to Zambia. In Zambia we were living with a friend of that mother Priska.

I was 12 years old then. We couldn't have that life of going to school because my father had many children. He took some of his children to school and some were staying at home. Only three went to school. I didn't have that life of going to school.

In DRC when I was small I went to school. After my mother passed away I didn't go to school. Just the life of the village was my life, digging in the fields.

But I used to write what I could, to teach myself. I remembered the stories my mother told me and I tried to write them down every day. Also, I had a friend who went to school in Zambia; she was called Sandra, and she used to teach me. I would go to her place and she tried her best, and she told me to write my name. She is still in Zambia. We send each other letters. We are the same age, and her birthday is the same month as me. She has stopped school as she has matric, and now she is looking for what she can do now. I put her in my suitcase. These two girls here are us. We used to like each other so much. I would go home with her and she would teach me.

But then my father died too, in Zambia, and we were just living alone. My older brother had come to South Africa to work, and he heard we were alone, me and Pasco, so he sent someone. So he said, "I will help to take care of Aggie and Pasco." He sent someone

This is in Lumbumbashi outside where I lived in my grandmothers house we were playing with friends, that time I was really small

to fetch us. We came here to his house, but now his new South African wife does not want us. Last year she changed and she said, "I want to stay alone." So now I just live with friends. But it is difficult, because I don't have money to pay. I have tried to find work.

I was working now for these Somalian people. The lady was so nice, and they say they will pay me R500 a month. They have five babies and I can live there. I love looking after the babies. It was nice, I liked it so much. The problem was that guy, the brother of the man in the house. I just ran away.

I don't want to go back. From the first time he saw me he is just talking, talking. And last night he saw there is nobody, so he came where I was sitting on the bed and he is just forcing me. So I ran away. I just ran out of the house, and I am not going back!

Pasco also lives with friends. He is helped by this man, Gerd, who buys food for him. They cook together.

She is just lekwerekwere, she has nothing

The other time, I was walking alone in the street and there was a group of four boys, and one of them called me and I didn't go. And he came and klapped me on the face, and I fall on the ground, and I didn't want to talk, because if I talk they will realise that I am not a South African and they might do more harm. It is very painful that you don't feel safe at all, all the time. Especially when you see a group of boys coming.

The one held me tight, and the other guy kept saying, "Man, leave her alone." But he carry on holding my hands tight and threaten to hit me, and I didn't do anything wrong. He said to the other, "Don't

worry, man, she is just lekwerekwere, she doesn't have anything."
And the other guy forces him to leave – then he left me. I am not
safe; it doesn't matter whether it is during the day or at night. I walk
alone. I am always scared. I don't feel comfortable when a male
person greets me because I always think of negative things, like
what he wants from me now, and you find that sometimes he was
just greeting me. I don't feel safe ever, to be honest with you.

I think we should be friendly to South Africans, but the challenge
is, you can't be friendly to everybody because some won't be nice
to you, even when you are friendly to them. I had a friend and he is
a South African boy, and we were working together at Joubert Park,
and he hand me his jacket when we were working, because I was
not wearing anything warm and the weather changed. As he was
giving me his jacket he expected something else from me, and I
didn't even think of anything negative. When I return his jacket he
told me that he want me, and I said, "We could be friends since you
were nice to me." He said, "I don't want to be your friend only, I want
something more. Otherwise I will kill you."

Then I met him on Sunday. He said, "I hate amakwerekwere who
are coming to our country. Look now, I was helpful to you but you
treat me like shit. You know that I am a bad boy and I can kill you."
I was very scared. My whole body was shaking. He said, "This is the
last warning. Otherwise I am going to rape you or kill you." He said,
"I gave you a lot of chances but you don't want to go out with me.
I think I should use force, so that you can see that I am serious."
Those kinds of things, they don't make you safe at all.

I don't have someone to talk to. The only people I talk to are some
people in the group; otherwise I don't have someone to talk to. If I
want to talk to people, I have to wait for Saturday or talk to my

brother, and sometimes he doesn't take me serious. I don't blame him – he is a child himself. Last time I was nearly raped by the guy who was offering me a job, and I told my brother, but he didn't take me serious at all. I don't have someone to talk to, and no one is willing to listen, and they don't see even when my life is in danger. Even those four guys, they could have raped me if they wanted to, but I was lucky that people were passing around. I don't feel comfortable any more to tell people about the bad things that happen to me, because it seems like people think I am just talking, and it hurts to see people thinking like that about me.

I love these little ones

It took Aggie a long time to tell us about how difficult her everyday life was. I gave her a lift to Bez Valley to visit a friend one day after the group had finished. On the way I mentioned that I thought Pasco had lost weight. "We don't always have food. It is so painful to see him like this. I wish I had a job to earn money for both of us." We talked about the kind of job she could do.

The next week I noticed she had pasted a small message in her suitcase.

I am Aggie, as you all know. I am from Africa, the Republic of Congo, and I was working in the farm when I was in Congo. I did that because I love to work in the farm and help my family. Not only my family, but I love helping everyone. That is what I'm for!

I had noticed her gentle way with the younger children and how the younger girls always sat with her during lunch, sitting close and sometimes even leaning up against her. I suggested we look for a job in child care. She began to work as a volunteer at a local child care project.

I love these little ones. They come for art lessons. Every day we go to fetch them from the crèches in the buildings. You will see us walking in the street with all these little children going to art, and then we take them back at the end of the morning. I love to do this work. I am wishing for a job in a crèche soon, because I love these little ones.

But she still waits for the job, and also talks of going home – back to the trees and fields she remembers from her childhood.

> e Live here
> soub in a
> at we Live
> h Pasro is my
> g brother.

> Im as you all
> kno. I came FRom
> africa the Republic of
> Congo and I was working
> in the farm when I was
> in Congo I Did that cause
> I Love to work in the
> Farm and to help my
> Family not only my
> Family but Love helping
> everyone that what Im
> for !!

I would like to go back to the farm, the trees and the river

Sometimes you just feel like going back, but there is no one there, maybe, in DRC, that is the problem. I would go back to Congo because in Zambia they are sending people to prison who don't have papers, so it would be better to go home to Congo where I come from. The time they left there, they just left everything there. They just left the house and everything. I heard that one of my aunts is there at the farm. But we don't know if our house is there saved or not.

For Pasco, he must stay, because he is at school. I would like to go back and look for that aunt of mine. There is a guy who lives here, a friend of Gerd. He said he will try to find her. The war is stopped there and they say there is coming peace, so if I can find my aunt it is better to go back. She is my mother's sister. They are real, real sisters. If she can have a place to stay I can stay with her. I would like to go back to the farm, the trees and the river in Congo …

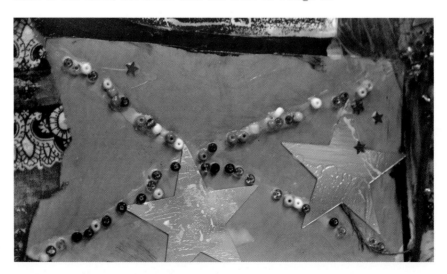

Refugees from Democratic Republic of Congo

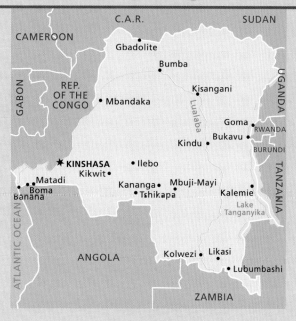

A large and potentially rich country, the Democratic Republic of Congo (formerly Zaire) has been at war since the mid-1990s. Conflict was touched off by the arrival of Rwandan refugees, and in 1997 Laurent Kabila toppled long-time strong man Mobutu Sese Seko. The next year Uganda and Rwanda sponsored an insurrection against Kabila. Parts of the country were then invaded by armies from Zimbabwe, Angola, Namibia, Chad and Sudan, many collaborating with brutal Congolese militias. After Kabila's assassination, his son Joseph took office and negotiated the withdrawal of Rwandan troops in 2002. By 2003 a transitional government was established but fighting continued, especially in the north-east.

Dense jungle in the east makes it is impossible to know how many have been killed, but estimates are between one and three million. Another two million people were displaced within the country and hundreds of thousands fled to other countries. Some from war-torn regions are still leaving the DRC, while others are now being repatriated into areas where fighting has ceased. Little help is available to these returnees to rebuild their lives.

Paul's suitcase

Paul is 18 years old, was born in Rwanda, and ran away from the country during the genocide. He lives in a shelter for unaccompanied refugees, and attends school in Berea.

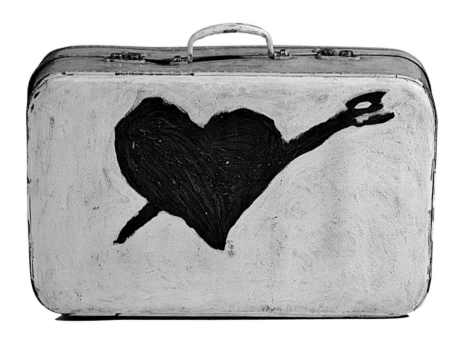

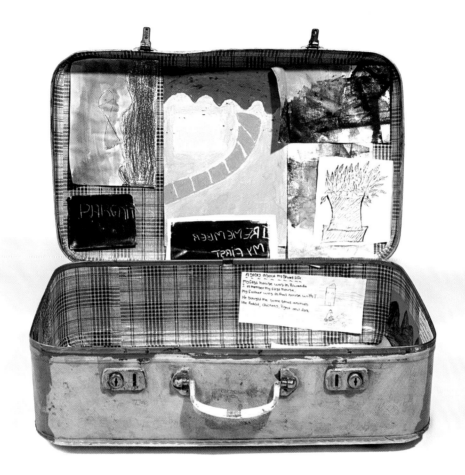

Six chickens, four pigeons, five goats, three ducks but no rabbits

I have a memory inside my suitcase from when I lived in Rwanda. My first house was in Rwanda. I remember my first house. The pictures inside my suitcase show my first house in Rwanda. I am not sure if it is there still. Maybe they break it down ...

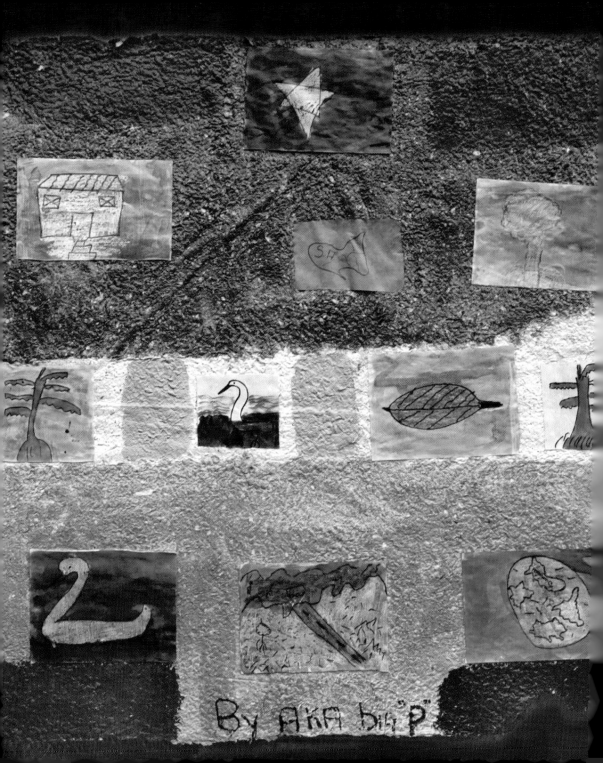

By AKA bin "P"

My father was in that house in Rwanda. He was teaching me to look after the animals. I had six chickens, four pigeons, five goats, five ducks. I have those ducks in my mind. My dad used to buy ducks for me. He would say, "Parfait, this is for you, keep it, it is just yours." He was trying to teach me how, when he is not in front of me or beside me, how I can run my own life with success. "This duck is yours, treat it well." It was so small and I must look after it until it gets big. He said, "It is yours, and you must keep on doing this and you will see the meaning of this some day." I am trying to see the meaning of being able to look after myself. But not really yet, because now I am not able to run my own life yet, I am still looking at people to help me.

I always wanted a rabbit and I was always asking my father, "Can I have a rabbit? I have never tasted a rabbit, can I keep rabbit?" My father he said he was going to get me a rabbit next time he goes to town.

But he never went. We had to run away. Now I cannot find him, I cannot get hold of him. I do not know where he is …"

I haven't told no one this story

Paul was everyone's favourite in the group. He had a huge grin and a gentle way. When we began the suitcase work, he did very little artwork. He drew one or two flat and very grey pictures. He painted his suitcase in one colour and drew a large black heart on it. He often took his suitcase and hid it away, so we could not see that he had not done any work. Sometimes the other children drew pictures and said they were his; they realised he was not doing any work and tried to help him out. We allowed him to work in his own time and never commented on his lack of artwork.

One day he began drawing ducks in pencil. They were simple ducks, like a small child would draw. When we asked him about the ducks, he told us how his father had taught him to keep animals when he was young.

He did not say any more, and he carried on for many weeks drawing ducks, and sometimes the house where he lived with his father. All of these were lovingly pasted inside his suitcase or bound in the journal inside his suitcase.

Then one Saturday morning he called me, and said he wanted to tell his story. We sat under the tree in the centre of the grass quad at the school, away from the others. In an expressionless voice with no emotion, he told how he had seen his mother killed in Rwanda. He told how his father had been taken away while they were refugees in Burundi. When he had finished telling the story he said, "I haven't told no one this story. Lots of people have asked, but I have never told anyone."

My dad gave me my name. My dad was a businessman in Rwanda and Burundi. That's why he couldn't ever be free. In my country they don't like businessmans who are rich. We used to move a lot. There were always problems, wherever we lived.

I do remember one time. My uncle was at home, and me and my mum and sisters. I remember that day. My mom cooked a rabbit. It was about 7 o'clock. We were sitting in the lounge, talking and sitting, making some fun. I was so young. And my sisters – I am from a family of seven children, I'm fifth. Mama was teaching us some stuff, games – how to carry your friend on the back, how to jump over each other. So we're having a nice, great time.

There was my mom and my two uncles, and all of us, and other visitors. Then these men came and wanted to take everything from our

house. We knew they had come to rob, because my dada was a big businessman and they did not like him, and they wanted to kill him.

They told us that they wanted my dad. Luckily my dad had just left. They said, "If your father is not here, then we want everything in the house." My uncle was a solider and he said no. So they began to fight. Can you imagine us with our hands fighting the machete?

I ran inside screaming. They said, "Why you screaming?" They took my shirt, they want to cut me in half. Then my uncle he took his hand, on top of me. They chopped his hand in the middle. When I remember that, I get so sick. They wanted to cut my face in half. My uncle saved my life. I don't know how I was going to look if they should cut off my face. They wanted to kill me – chop two times – and that was very frightening. I still remember it. I still see it.

We called the police. Then we heard the police and the people ran away. All the house was full of blood. I don't know how they survived, just made it. Others were all hurt, except my mom and my little brother, also me. My dad had saved us. He was on his way home and the neighbours had said, "Please, don't go there, lots of trouble, screaming." So dad call the police.

The thieves said, "We will be back." All were injured. My dad decided to drop the business and do nothing. Things were getting serious. He left everything. We moved just nearby, not at the same place. We got to live in a small house in Kigali. People must see us as themselves – we did not want to be different.

They said they would be back. One day they came back. I don't know how did they know where we had moved. And they sent people in the middle of the night. They wanted a large amount of money. My dad said, "Sorry, I can't get all that." They say, "Okay, then say goodbye to your life." But my dad was prepared. He had put the money in the house. We thought our dad was going to be killed. But

he gave them money. Then they said, "You know what, old man, we were here to kill you but you were ready for us." I'll never forget that word. "Old man, we were here to kill you but you were ready for us." I was in the house screaming. I was then about nine. So my father was saved.

But in the war, my mum was killed. We were living in Rwanda by this time, in 1994. I was ten. What happened was, my father had a sickness called heart attack. If he do movement, he get so terrible. And anytime he could die. My dad said, "War now is coming. People are dying anytime, anywhere. So guys, how about this? Leave me alone, because I don't have that long way to go." He wasn't that old, maybe about 50 years. "I'm okay," he say, "but I don't think I'm going to make it. My heart pressure. I'm going to die on the way. Leave me alone." And he gave us money to make our way to Burundi.

Then my mom said, "We never can leave you." My mama's friend said, "Your husband mean so, you have to do what he say." So she agreed. We took organised transport. It was in the war. People were getting killed with knives. All of them. The cars were a lot on the way to Burundi.

My mom says, "Drop the car, let's just walk, because we can't make it in the car." We walked. And then there was shooting. In front it was me and my mom. My sisters were lost by now, just me and my mum and little brother. Then they shoot her in her intestines. I just stayed with her, with my brother. Many people were walking past. Then her friend came and take her away and put her in a car.

I said, "Okay, if this is happening, I'm going back to Rwanda to tell my dad." So I took my brother and I walked back the other way. All the people were coming this way and we were walking the other way. I was so young. All I could think was to go and report this to my dad. It was in war. He couldn't do nothing, it was very far from home, but I was walking to tell him.

On my way back I meet with this uncle. He said, "What are you doing? All the people walk one way, you're the only one person going back. All the people are going out of there, what's your problem?" I said my mom is dead. He said, "Okay, don't worry." He put my brother on his back and we went across the border.

We heard that my mom was dead. We sent a message to my dad. He said, "I'm going to try my best to come and see you guys. I can't leave you alone like that."

He just arrived and say, "We got to move out of here. We got to move again." We walked. My dad was sick. He walk slower, slower. We would walk two metres, sit down, drink cold water. About three days of us walking.

This one lady came. She never even knew us but she said, " This father have a serious problem. Can we help your children? You will meet them if God want to." Dad said we can't. "We must die together. Must stay together." She say, "Don't think you're going to make it. You have a sickness. I don't think you can escape with children and all of you make it. How about we take your children?

You are left here."

He say, "No ways." The lady went. She gave him a water to drink. We had no water. We came to a house and we stayed there. That is where they come and take him away, my dad. My dad said, "If you see them calling me, don't cry. Pretend you are not my child. You just walk away and save your small brother."

They came at 6 o'clock. We were listening to the news. They come. They put him in a truck. Just take him. I had no idea what's happened. That's the last time I saw him. That was the last day to meet my father. That was my last day. I don't know if he's still alive or not. No clue.

My brother and I were alone now. The neighbours knew what happened. They took us to government office, and then they went to put us in an orphanage in Burundi. Me and my little brother, maybe he was six or five years. My brother was called Claude. I think he's in Kenya. This Holy Sister said, "There is better orphanages in Kenya." She used to travel countries. She said, "Do you mind if we take your brother?" I had no choice, because Burundi was also at war and any time I could die. They can only take one of us. I said, "No problem." Then they took him. They used to come to tell me what's happening. I can write to him in the orphanage. But I haven't written. He don't even know me.

Then I found my uncle. Connections helped him find me. Because these Holy Sisters, they had every orphanage in the whole country, and they put up pictures with your name, and go to ask people. I don't know how they find out, but they did get my uncle. He came to fetch me. He just brought me here to Johannesburg.

That's it. It is a sad story. I get on with my life. If I think, it's too much. I haven't told no one this story. People don't know this. They don't deserve it. It was difficult with the suitcase. I wanted to keep

my story separate from me now. That is part of life but it is too much, it is too much.

As he finished the story he put his head down on his knees and I put my arm around him and we sat still for a very long time. Then Diane called us for lunch. We walked back to the comfort of noisy voices, paint, Pasco telling jokes, and warm and tasty Kentucky chicken.

Slowly, Paul began to show signs that he was starting to make the story a part of his life, and not keeping it separate: a step that trauma psychologists say is important. He was also beginning to rewrite his story. There were signs of him beginning to see himself not only as a victim of the genocide, but as a survivor, a hero even.

Soon after he told me his story, we went away on weekend retreat with the group. The retreat began on a Friday evening with a lighting of candles, to remember people we love and have lost. Paul lit a candle for his mother and father, brothers and sisters. And then, just as we were about to end, he stepped forward and lit another candle.

This candle is for the boy who was me, the ten-year-old boy. The boy who survived, who walked and walked and survived, even though he was ten years old and did not know what was happening around him. This candle is for the ten-year-old me.

Some months later we were working on large journey maps. The children were using magazine images on a collage to represent their journey to South Africa. Paul had been cutting out small pictures of shoes from a *Getaway* magazine all morning. They are arranged in pairs on the map he had made, almost 30 pairs of shoes. I asked him, "Paul, why all the shoes?"

They remind me that I walked. I walked and walked and walked. I was a small boy but I walked. They remind me that I was a survivor, that things were very bad and I was only ten years old, but I walked and walked. And I survived. The shoes remind me of surviving.

I did not have any phone number in my head

One Saturday there was a quiet hum of work in the art room; everyone was working quietly on their collage maps. I was helping one of the small children with a drawing when my cell phone rang. It was Alistair, saying he had just had a call from Paul. He has been arrested for not having papers and was in the cells at Hillbrow Police Station. He said he would call a friend of Paul's to see if they could go together to get him out. I passed the news on to the others. The older boys were worried. They talked together quietly instead of working. We heard no more that morning. We had lunch, packed up, and Diane and I left, promising to let the boys know if we heard anything.

Late that night, Paul's friend phoned to say that Paul was out. The next week he added a number of drawings to his suitcase, drawings of the arrest.

I was coming here to the art without expecting nothing on my way. I didn't expect nothing even though I see police behind me. I knew I had papers and stuff so no one can arrest me, and I wasn't even really worried. Then they came and ask me about my papers, asking me, "Where is your papers?" I took out the photocopy that I usually use – it has a stamp on it from Hillbrow Police Station. So the strange thing was, they read the paper and say, "Where is your original?" And I said, "I do have an original but it is at home, so I have a copy that have a stamp to prove it is not fake, not artificial." Then he check out the paper, and said, "This is not allowed. You must come to the car." At the police station I try again to explain and the policeman say, "I am going to slap you!"

Okay, I need help, I was thinking. I thought, "No one knows where I am." I think, if I didn't get help, something will happen to me. I did not have any phone number in my head. I found a paper and it had Alistair's number, and I was so happy because I had someone to phone. I called Alistair, and he said, "Can I speak to policeman?" And he was rude to Alistair, he couldn't just be nice to Alistair. I was thinking, something need to be done here. He is policeman, and he has to take people as people. He mustn't think he is on top of everyone. Then Alistair asked, "What did the boy do?" And he say, "He has got photocopy paper." And then after he dropped the phone on Alistair.

Alistair called Jacques who came to get me out. When he got there they said I was out, but I was still in there. So he left me there. Maybe at 5 o'clock they came and called me and said you can go. I didn't know how can they let me go just like that. They didn't tell me nothing.

I love nature, especially the trees I walk past every day

After we have worked on our art and eaten lunch, we often sit under the tree at the school and talk. This is the opportunity to check up on each other, to ask about those who are missing. The group has become an alternative family for many of the children, especially for Paul. One Saturday we were talking under the tree, and Paul asked me, "Glynis, can I ask something? If you are not sure what to do and you don't have family, who can you ask for advices? Do you think it is good to make

your own decisions? Does a person need somebody who has experience, or are your friends enough? Can you believe in them and trust them?" I suddenly realise what it means to be alone with no family.

I pass this wall in the morning when I come to school. When I walk to school there are some trees that I love. I walk under them on the way to school. Sometimes I am in different moods, but the trees make me be happy.

I think about that I need to do something with my life, because I've been saved a lot. A lot of people in my country say, "You know what, when we grow up we're going to be soldiers, and go and revenge, and take guns and kill people." I promised myself I would never do such. I don't want to be a soldier. The kid who killed my mom, let him go. I knew him. I can never do nothing, never take a weapon and try to revenge, because I'm going to change nothing. Hate makes things more serious, and my country is going to go lower and lower and lower, so there is no solution. To say "See your mom dead, grow up and go to kill people," that is no solution. There is no solution. I will never, never take no weapon.

Refugees from Rwanda

The small mountainous country of Rwanda has seen some of Africa's most horrendous violence. Three years before independence in 1959, the country's Hutu majority overthrew their Tutsi king. Thousands of Tutsis were killed and 150 000 sent into exile. The children of these refugees later formed the Rwandan Patriotic Front (RPF), a rebel group that launched a civil war from their base in Uganda in 1990. This exacerbated already acute ethnic and political tensions, which peaked in 1994 in the form of a three-month killing spree, during which approximately 800 000 Tutsis and moderate Hutus were slaughtered. Fearing retribution from survivors and the invading RPF, some 2 million Hutu refugees fled to neighbouring Burundi, Tanzania, Uganda and Zaire (now the DRC). In an effort to track down génocidaires hiding in northern Zaire, the RPF and its allies invaded that country, triggering a civil war that has yet to be resolved.

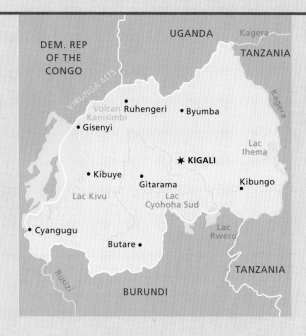

Many refugees have now returned to Rwanda, with tens of thousands of them being pushed back by the Tanzanian government at the end of 1996. However, ten years after the genocide there were still an estimated 46 000 Rwandan refugees and asylum seekers in exile throughout the continent. Many of the region's leaders now claim that conditions in Rwanda no longer justify this, and are withdrawing refugee status for Rwandans. However, despite encouraging the return of refugees, the RPF government led by Paul Kagame has proved increasingly intolerant of dissent. Many refugees fear persecution if they return, while others fear they may be prosecuted for supporting the 1994 genocide.

Rwanda is struggling to rebuild its economy and prevent further violence. Despite a fertile ecosystem, land is in short supply and food production often does not keep pace with population growth, while low prices for coffee further hamper the economy. As refugees return to Rwanda, competition for resources is made more acute by an increase in population and mutual suspicion. Rwanda also hosts small numbers of refugees from Burundi and the DRC.

Jenny's suitcase

Jenny joined the group when she was 16. When she joined the group she had a baby, Jacob. She is now 20 years old, and lives in Rustenburg selling clothes at an informal market. She came to Johannesburg from Burundi with her younger sister, Françoise, when she was eleven years old. Soon after she arrived in Johannesburg, a Burundian woman became a guardian for her and her sister. Her son Jacob still lives with Jenny's guardian and her family in Johannesburg.

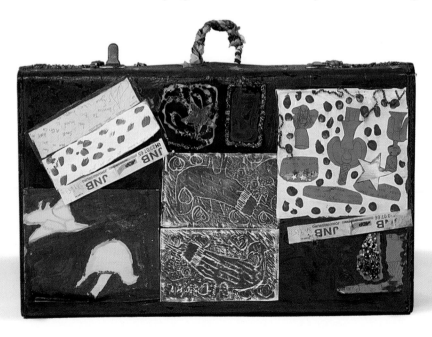

Nothing was there, not even the bones

Jenny was not one of the initial group of children that I met in 2001 in the JRS office, as she had to stay home to look after her small baby. I met her when I took the smaller children home to the flat one afternoon. I invited her and her baby to join the group. During the first workshops that Jenny attended, she did no work at all. She wandered around talking to other children, washing paintbrushes, pouring juice, but resisted making any art. She had a suitcase, but it remained bare.

She wanted to tell her story so that it could go into the book, but she did not make any visual images of the story. We sat under the tree at the school while the others did artwork, and she told me the story of her remarkable journey to Johannesburg. She told the story easily and with humour, marvelling at the bravery of her younger self. But clearly there were parts of the story that had not been told, parts that were too hard to tell.

I remember our house and the ducks. I was feeding the ducks always. It was in the village. But when I was a small girl I went to live with my aunty in town. I was too small, maybe three.

You know, I did love my mother so much. But maybe my mother, when she was pregnant, she hate me – that is why she took me to my aunty. She never come and look for me … I think maybe she loved

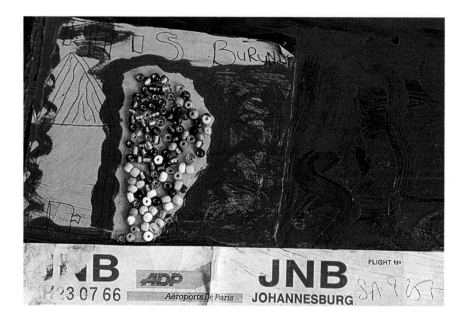

my sister more than me. That is why sometimes me and Françoise
don't get along.

Then my parents died. They just burned the house of my family.
All my family was living in that house – my mother, my daddy, my
other aunty, my mother's sister, my brother, my sister. I don't know
why, still now, why they burned the house. I wish to find out. My
aunty did not tell me.

At this time my aunty was hiding it away from me, that my mother
is dead. Then they just decide to take me to the village, and we just
find the house burnt. At that time I was six, turning seven.

The neighbours told me my parents had died in the house. They
said they tried everything they could to get people out of the house,
but they could not. Nothing was there now, not even the bones. All
burned … At that time I was very young. I did not know nothing, I
didn't even know what "to die" means. I just saw the house burnt,

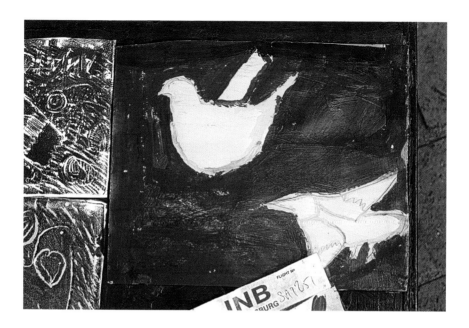

and then I said my mother is not dead, she is just somewhere. But she was dead.

I even today remember that my aunty told me when I was very small, "When you grow up, don't forget to look after your mommy's house." I realise now I grow up … I don't know where my mother's place is. The name of the village I know, but I don't know where the house is …

This was the time when I met my little sister, Françoise. The time when the house burned, someone took her and raised her, while I was raised by my aunt. One day my aunty came with her to me and said, "This one is your sister." I said, "I don't know her. How come this one is my sister?" By this time Françoise was one year old and I was six. She carried on to live with the other lady, her stepmother. I lived with my aunt.

Before my aunty passed away, I was six. She went to the hospital

and stay about one month, and she was telling me the story how it is they grow up, she and my mother. And she says no matter what I do, I must never leave Françoise behind. Wherever I go, I must go with Francoise. And that is why I never leave Francoise behind. No matter even if she gives me a big mistake, I won't leave her.

When my aunty died, I have to live with another lady. She was not good to me. That lady she used to tell me, "Your family, they were rich. Everything you want they just give you, and you end up like this!" At that time I was just a kid, just looking at her and seeing if I am happy with this family, but she doesn't even care about me.

The other children would go to school, but I remain, even when I know my father leave money, my mother leave money, my aunty leave money. Francoise was happy, because that family was taking care of her very nice. Until the time the war start in October 1993.

There was fighting all over, so we had to run to Zaire. They were fighting everywhere. We ran together, Francoise with her stepmother, and me with my stepmother. We walked on foot.

After we reached the border, Francoise and her stepmother went to Tanzania. My stepmother and me went back to Burundi, because the water in the camp in Zaire was so bad. I was eight years old. Then in 1994 we had to run again, and we went to a village in Tanzania. We went by boat until Kigoma. At Kigoma we got out and stayed there, in '94 and '95 and '96.

Francoise was staying near where we were staying, but we had forgot each other. I used to play with her, but not knowing we were sisters. I used to get into a fight with her all the time. Then one day I cut her, so this kid said, "How can you fight with your sister?" I said, "She is not my sister." They told me she was my sister and that she had arrived there earlier than me. Then I went to tell the lady I was

staying with where Francoise was. I went to the lady staying with Francoise and demanded to know the truth about Francoise and I. She told me Francoise was my little sister who I had met when I still lived with my aunty in Burundi, but I had forgotten her.

I told this lady who was staying with Francoise how my stepmother was mistreating me. She said, "I will go and talk to that lady and take you." Then they were fighting and I was thinking, how can my life be like this? Then I was confused, because this family fight and this family fight, and I don't know where it will end up.

Then Francoise's mother died. She was having a heart attack. Then Francoise came to live with the same lady as me, the same stubborn lady who did not know how to take care of children. That lady, she does not want

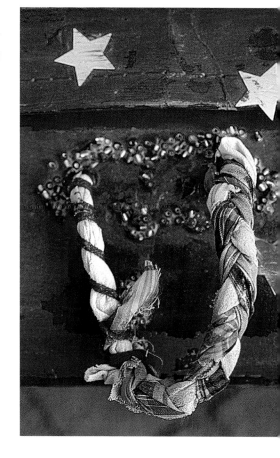

us to go to school, that lady made me to wash her children's clothes, that lady made me to clean the house, everything by myself. And then she was having a daughter who was bigger than me, eish, she did nothing.

Then I think, let me keep myself strong, like how my aunty says. One day I have to run away, because she beat me up for nothing. I slept on the street for three days, and this other lady found me and took me back. When she take me back, that lady beated me again.

She did not even want me to go to church. She would say, "That is not the church for your father or mother."

This is the day when I realised that my mother is not going to come back. My mother, she is gone forever. I asked God, "Why did you take my mum away from me?" And it was like, what can I do next? Now I am eleven years old, what can I do next? Let me do some action here that I will never forget in my life.

That day when all of them went out, I told Francoise, "You don't have to go anywhere, you have to stay here with me, because I have a plan." And then Francoise was stubborn and wanted to go with them. "What kind of plan do you have? Leave me alone." And I say.

"I am leaving, and asking you to come too. I am not going to leave you alone because I made a promise."

And we stay behind when they go – there we sit. I went to her room, I take the money and I take the taxi until Dar es Salaam. I knew I wanted to go to South Africa because my daddy, he was saying when I was small, "When my little girl grows up, I will take her to London." So I was thinking South Africa is London. Some other children in Tanzania told me about South Africa, too. You know, when you're going to play with children in Tanzania, they are going to tell you, "My mother is in South Africa, my mother is in Afrique du Sud." "Okay," you say, "ohh kaaay! [*She drops her voice to a whisper*] I think one day I will go there. But I don't know how will I go there; I will have to make a plan. Hmmm ..."

Then every time I was serious, until that stepmother gets shocked and thinks, "There must be something she is planning." She asks me, and I say no, nothing. She says, "A small child like that, your mind is thinking forward. What are you planning?" I just keep quiet.

The day when I stole the money I was so afraid. I was asking myself, "God is going to punish my mother? God is going to punish me?" And I stop ... Then, "Agh, let me take it. I must go!" And I just take the money and I go ...

I think maybe they have been looking for us for long because of that money [*she laughs*] and they never find us ... [*She laughs again*].

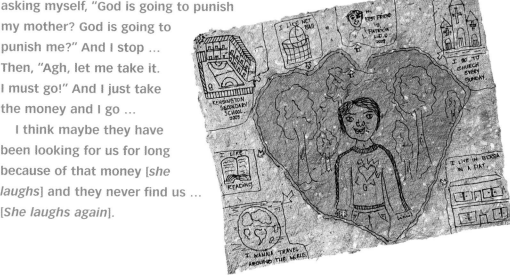

In the place where the bus ended they spoke another language

While Jenny and I are talking, Jacob, her three-year-old, runs up to show her a drawing he has been doing. She turns to him and looks closely at what he has drawn. "Wow!" She touches his arm and tells him to go and draw some more. He turns his head toward her, beams at her, turns to beam at me, and runs off with pieces that have been glued to his drawing trailing behind him. "He really loves you," I say. "He came especially to show you his drawing." She laughs gently. I look for opportunities to reinforce his love for her, as she often tells me that she does not know if she loves him; he does love her, though, just in the way she loved her mum and her aunty. She continues with her story.

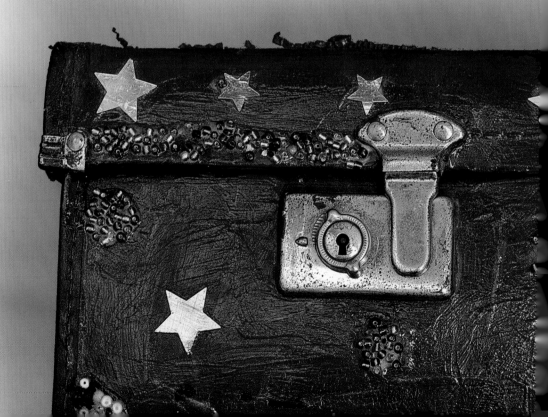

We went on a bus with some of the money. We took three buses. One bus dropped us here, and we give money and then the bus drop us here, and we give money and then again, until the place where we see this is the border to South Africa, because it says there, "You are now leaving Zimbabwe." I remember the sand was like the beach.

In that place where we began, they were speaking Swahili, but in the place when the bus ended up they spoke another language we did not know. I wanted to tell people we needed to go to South Africa. I ask myself, what language I going to talk? I was talking like a sign language; I was drawing down for them. They can't see, they were asking, "What is this?" I was asking myself, "When are they going to understand? When?" And then we gave our money to one person, and he ran away. But there was another one who saw him, and he said he would help us. We went with the man and had to walk through the bush and walk, we walk, we walk, we walk, we walk, shoo shoo shoo! And then we cross a river. And then when we cross that river, that man said, "I have to leave you here now." I was eleven and Francoise was eight. Two girls in the bush now, on our own with that man ...

We just want to say, "How are we going to get over this fence?" Because there was an alarm. How we going to pass, because that man said, "Don't touch the fence." Then we just find a way to open the razor wire. It is long, that fence with razor wire! They don't need anyone to pass. How we going to pass here? Let's jump. And I ask myself, "How is Francoise going to jump?" But we pray to God, "Oh God, please help us, please do something." Then I have to pick up Francoise, and Francoise is going to jump. We even got scratched, and the alarm cry, and the police come and we have to hide in the grass. The police pass two times. Pass, pass. And they didn't see no one.

Then, when we hear it is quiet, we just stand up and went to other side there, and drink the dirty water. And we went to the road. The first taxi didn't want to stop; the second one didn't want to stop; the third one was a man and he just stopped. And he ask us what is wrong, and we say we want to go to Afrique du Sud. "Oh, Afrique du Sud, that mean South Africa." He just said, "Come quickly, come quickly." And we went into the taxi. Inside there, we hide. The police tried to stop him and he never stopped. They did the gun like this, and he never stopped. He take the bus like this, quick, so quick, and he never stopped. And we were hiding in the taxi.

It said "Johannesburg" on the paper

Then we got to Musina and we said, "Oh, this is it." He was asking us, Can we go and stay with him, or do we still want to go? We tell him we still want to go, so he say okay. He buy for us food and give us money. We didn't even know how to use that money. He cut for us a ticket, and we were asking how we going to talk to this man, and we were saying we don't know his language and he doesn't know our language. And me and Francoise, we were talking and we were talking, and we find another guy from Burundi. He was selling sweets here on the station, and he came and said, "You can come and stay with me." And I say, "I don't stay with strangers." And he say, "Okay, that is fine," and say, "Just take this train. It is going to take you straight. Don't go out, don't go anywhere, just go straight until the end of the station."

And he find a piece of paper and he write for us "Johannesburg" on the paper. This is the station the train is to stop. All on that journey, each time the train stop I have to take that paper and see

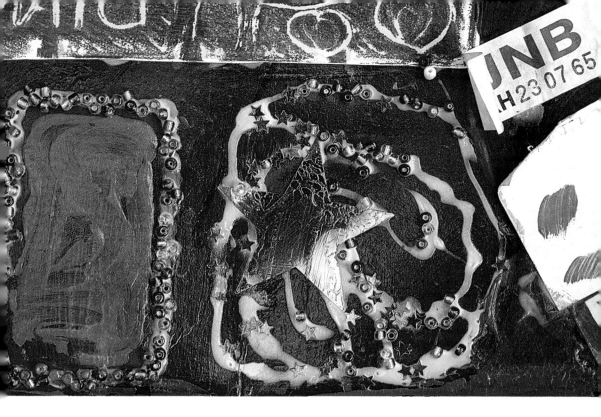

what the station look like. Each time I say, "No, we are not here."
After a long time I say, "I am tired. I am going to get out," and
Francoise say, "Remember, we are going to get out and we won't
have anyone to help us." And I just say, "Okay, let's go on."

And we went. We went until the end, and when we reach Park
Station the language is so funny! It was so funny we were even
laughing, and some other guy want to klap [hit] us because we were
laughing at him.

As Jenny talks, I have this mental image of the irrepressible and often cheeky
Francoise and her older sister sitting in the train, giggling at the way South
Africans speak. After the trauma of such a journey, and in the face of the uncer-
tainty of the future, these two remarkable children find something funny in their
situation. Once again, I marvel at the resilience of these children's spirits.

He was asking us something in all funny languages, and we laughed at him. Then we decide, "Eish, Francoise, let's do this – let's walk until it is night, and we are going to sleep anywhere we get by night." So we walked. From Park Station until Bez Valley we walked, and then when we see it is night now, we stop and sleep there. There was a corner by the garage and we sleep there.

There was even kids passing there, coming from school. When they pass we play with them, and then they leave us and go to their homes. It was like we made that place our home. At first we couldn't see no one to help us. First week no one, second week uh-uh. At this time I ask myself, is it better we should go back to Tanzania? Here it is winter, it was cold. But the third week, ja!

At this time we used to see CJ and them, passing and going to school and coming back. And they were looking at us, and we don't even know them. Then CJ's mother was going to work and she just saw the kids who were sleeping there, and then first she pass us, and then she come back again. She was looking at us, and we were sleeping, and I was shy to be looking at her. I ask myself, She going to laugh at me? Or maybe she going to take care of me, the way the mother in Tanzania did? She stand there and she wake us up. She asked me in English, she asked me in Zulu. She asked me in Swahili, and yes, I answer her and I understand! "When did you come?" We tell her we have been sleeping here for one month now, and she was asking me too much questions. She ask, "Are you Jean's daughter?" And I say, "Yes, I am Jean's daughter, but there are so many Jeans in the world." And she says, "Yes, but Jean was my best friend." And I tell her, "I don't trust you," and she say, "Why? You have to trust me because your mother was my best friend. I was walking with your mother – we take the business to Zaire!" She was crying and she has to hug us and she take us to her home.

It was just near – it is like we were sleeping there, and their room was, like, there!

She even had my photo, my mother's photo. When I found her, she say, "Come with me, I am going to show you something." And she show me a photo of my mother and daddy and me, and photos of me when I was a baby, and she had photo of my mother's wedding. I said, "Okay, she is my mother's friend. I have to live with her now, she is my mother's friend."

Then she bath us and we have to sleep and she go buy for us food. And when CJ and them come from school, she shout them, "Why you didn't tell me you see these kids? Today it is them, tomorrow maybe it is going to be you!" I have to tell him it is fine. So we live with CJ's mother till now. Now we have a home. I think my mother she is looking after me, maybe she does love me …

There are some other parts to this story that aren't good – that I don't want to talk about. I have not told everything …

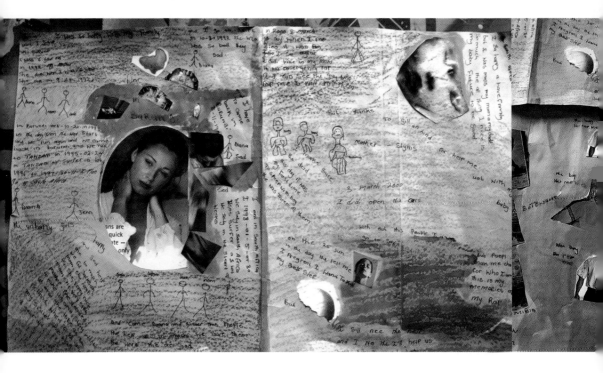

A very big piece of paper for a very big story

After telling the story of her journey, Jenny stopped coming to the group for a while, because she was helping her foster mother sell clothes and shoes in a hawker's stall. One Saturday she returned, and once again did no artwork, but chatted to the other children and helped. Her suitcase still stayed untouched.

At the end of the workshop she drew me aside and said, "Next week, can you bring a ve-e-e-ry big piece of paper for me? I have a very big story to do next week." The next Saturday she was waiting. As soon as the room was opened, she withdrew from the group with a pile of collage materials and set up a table in a corner of the room. She began to construct a collage, working with great intensity. No one interrupted her, but a facilitator sat at the other end of the table and quietly

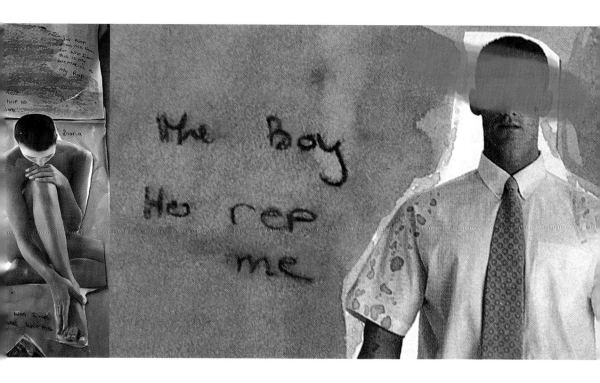

did her own artwork. This told her that we were there to support her, but she could choose when and whether she wanted to ask for more support than that. She worked for the entire workshop, and then together she and the facilitator put the collage into her suitcase, locking it away until the next week. She told us that she did not want to talk about it, and this was respected.

For four weeks she worked intently on the collage, locking it away at the end of each week. Then she worked on her suitcase, painting it red and decorating it with birds and gold stars. Her suitcase had no handle and she carefully crafted one from plaited cloth, showing us very clearly that even though bad things had happened to her, she was in control of her life.

At the end of the fourth workshop, she asked me if she could tell the story of the collage. The story is too painful to be in a book like this, but Jenny has agreed to let the collage be shown in the book.

After she had told the story, we worked on another layer of the collage together, working with tissue paper. This layer looked at what had helped her to survive.

Clearly the process was deeply healing, as from this point she began to make plans for her future, discussing setting up a small business to sell clothes on the street alongside her foster mother. Jacob still attends the group, but his mother now sells in Rustenburg, returning to the group for visits.

But her story is in no way over. She has grown into a young woman who knows her mind, and knows what she needs to do for her own healing, even if this means going back to Burundi to keep her promise to her aunt to look after her mother's house!

I was walking with my memory

In 2005, after six months of no contact, Jenny came to visit the group, saying she had recently returned from Burundi! She had gone to look for her mother's village and find her mother's house. This is the story of her journey back:

I had to go back home because I was sick. When I feel sick I went to the hospital by Krugersdorp, and the doctor he take my blood test. and he say, "Hmm, there is not any sickness, but you look sick." And then I tell him, no, I am feeling bad on my stomach, and he say nothing is wrong. And then he call me and say, "Where you come from?" and I say Burundi. And he say, "Come tell me your story," and I tell him my story. And after that he tell me, "You have to go back home." And I say, "How? I don't even know home, I don't even have parents. Where should I go, where should I start? I don't even have transport." He give

I sa happy a have family
but I was miss my mam a my dad
so much the all thing I need is
my baby future to be good

With my

you

for help me

Skynis

Sill an kind.

Cars

on the 25 Jun
is the day the tell me
I pregrent I wanob To kill
my self slef

me transport. He gave me the money, and I had my own money, and I made it to get transport. He said I have to go home. I don't even know how my parents look, how my home is, but for myself, I felt I was being called by my mother. I had bad dreams. It was difficult – I wake up in the morning and feel like I had a fight with someone. Something is wrong with me. I have to return back home. Maybe the ancestors are calling me, maybe I have to go back home.

He gave me money and I had R2000 from selling clothes and cigarettes, and I add it and it become R3000. And then I go home. I take "City to City" to Zambia, and when I reached there I asked someone I don't even know how can I go. I just asked.

(As Jenny is telling me this story, we start to feel cold, and I run to the car to get us a jersey, leaving the tape running. And Jenny quietly says, "Ah, Glynis has left the tape on." Then she starts talking to the tape, leaving a private little message for me. "Ah," she says, "Glynis is a good woman. She helps people too much. I wish I could give her something, but what can I give her?")

If you just tell the driver in this Zambian language that you need to go somewhere, he say, "Don't worry, I will organise you." When we reach Burundi, I show them my passport and my ticket, and from there it was like I don't even know where I am going.

I crossed the border and took a taxi to town. I knew the town from when I was a little girl. To find my mother's house, I did not take a taxi – I just walked. I was walking with just my memory, nothing else, me and Jacob at the back with my bag, go, go, go, passing the jungle until I reach this other place. Sit down in the bush, thinking. What's bringing me here? I ask myself, what's bringing me here? Jacob say, "Mummy, where are we going?" and I say, "There is something we have to fix before I die."

I just saw four or five houses, and just sat there, near some stones.

I saw this woman coming, and my Swahili was difficult – she could only speak Kirundi, but when I just try to ask and explain to her, she say, "Ja, I know them." A lot of people had died in the war, but she had not run away. She showed me she had a big vegetable farm, and she said, "This thing is your garden, but I look after it." She thought we were dead, and I have to explain no, we are not dead. It is me, Francoise, and this is my baby. She even remembered Francoise.

I stayed about one week. I was just sitting looking at my mother's grave – it was not a real grave. They just put "Jacobs family" on a sign where the house burned, and when I got there I remember, "Oh, that is our name, not the name that is my guardian's, which is on my papers." I would like to change my name back to Jacobs. The whole family was there. I was crying day and night.

The lady was saying, "It is better that you are big and you come back home. You did a great thing to come back home and look at your mother's grave." I knew this too. That time when I was young and came to the grave, I didn't know nothing.

That lady, she gave me so many of our culture's clothes. She was too pleased to see me. She even say, "You are big, did they do for you the right cultural things? When it is your first menstruation, you go to your family so they can do for you culture things." I say, "Who can do for me a culture things? It was my first time seeing blood, I was stupid." So she make for me the beads and show me how to wear them. She made me to wear this. I did not even know what it is, but now I have it.

I was thinking, I still have people who care for me in Burundi, people who are even not born from the same stomach but they care. I did not know that I have people who care for me in Burundi. I thought if I go home no one will care for me, but there is people who care for me and people who care for my family.

I feel very much better, very much better. I even see that my life is not difficult like before. Before if I touch money, it disappear. I think to myself, let me make this, and it becomes wrong. I ask myself why. What's wrong with me? But after I go home there are no dreams coming to my life any more, nothing. I will just sit down and talk about it, no more cryingness, no more feeling sad. I just feel like normal people. Because even if I didn't see them alive, it is better I see their buryingness.

Refugees from Burundi

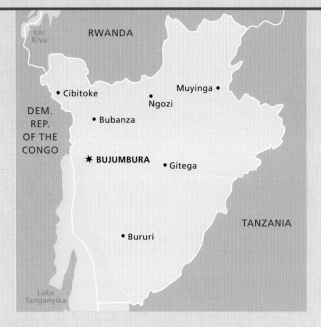

Burundi's history of intense and violent conflict dates back to the 1950s. Strong tensions remain between the country's Hutu and Tutsi populations and scores of political parties and militias vie for control of this small, resource-poor, landlocked country. Since 1993, conflicts among these parties have cause more than 200 000 deaths and displaced close to 600 000. Most of these fled to Tanzania where they were housed in purpose-built camps for up to ten years. Some Burundians are now returning from these camps, although many are reluctant to do so. Others have left to live in other parts of Tanzania or elsewhere. Another 145 000 people have been displaced within Burundi, many housed in government-run 'regroupment camps' used more to control than to protect.

Although most of the country's warring parties have now signed a peace agreement, Burundi remains desperately poor with a strong possibility of further violence. There is little industry and most people rely on agriculture to feed themselves and generate income – a tenuous situation because of high population densities, irregular weather and a scarcity of arable land. The end of the war has improved the flow of aid and investment into the country, but there are still limited economic opportunities for returning refugees.

Jacob's suitcase

Jenny's son, Jacob, has always been an important part of the group.
While he was still a baby, we all shared holding him. When he turned
two he threw terrible tantrums, and we had to have a group discussion
about how to deal with them. As he grew up he made art too. He had to
do everything the older ones did. He particularly enjoyed tidying up.
He loved to hold my keys and press the alarm button when we were
loading the car. And, of course, he had to make a suitcase too.

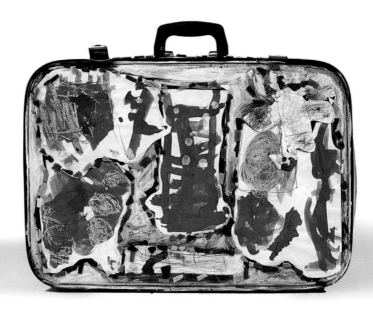

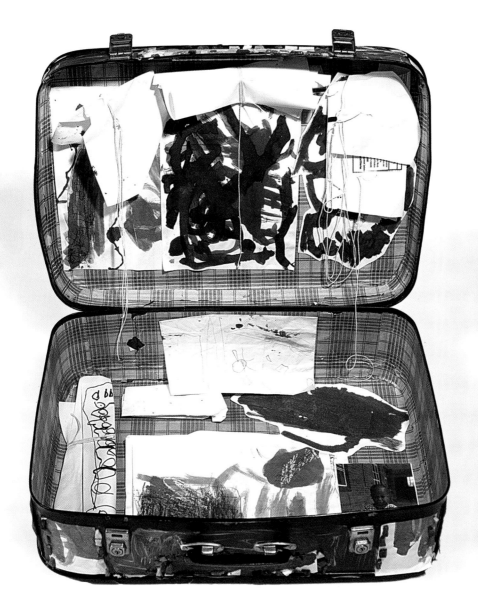

Tigistu's suitcase

Tigistu came from Ethiopia in 2002.
He joined the group when he was 16 years old. He left
in 2003 to look for his father in Namibia, and has not
returned to the group. No one knows where he is.

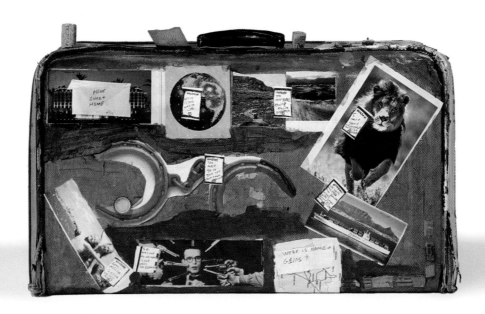

Every year, every day, I am travelling

Tigistu joined the group at the beginning of 2003. He chose an old, worn suitcase that had been on many journeys, with a number of luggage tags and airline labels attached. He worked on it energetically, using found images from magazines to tell the story of his journey to South Africa on the outside of his suitcase.

The suitcase tells about my journey to get here. Here, this picture shows where I stayed at home. This is representing my house, and this shows when the problems started to begin. Then I had to leave. This shows a map, and it told me the way I have to go to. I did not know where I wanted to go, but I knew I had to leave home.

I just left home. I left through public transport. We paid them for the transport and they dropped us at the border, and then we crossed the border. We walked. I stayed a few days in Kenya, and then into Tanzania. We had to pass the border at night. When we walked during the night, there were wild animals and we saw them. We also had to cross a river in a very small boat.

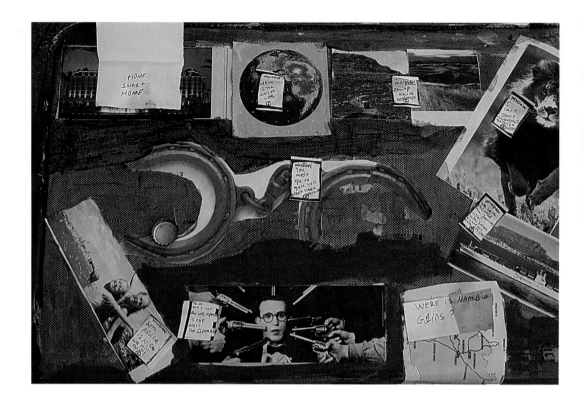

In Tanzania I was arrested because I did not have a passport, and this shows the handcuffs. But all the way there I was thinking, South Africa is a very nice place. Everyone I was walking with thought it would be nice in South Africa. We thought we would be comfortable here. But then when we come here, we realise it is not like we think. Here there are people with guns in the streets, and they hijack you. This is what this picture shows.

When I came here, I left my sister with my mother. My sister is six years old. Then I heard my mother had died, and so now my sister is alone. She is my little flower and I need to look after her now. My

father left my country before me, and we never knew where he was. Now I have heard he may be in Namibia, so I am going to move again to there to find him. So when am I going to stop travelling through borders? Every year, every day, I am travelling.

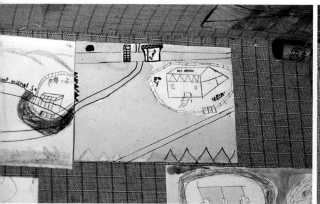
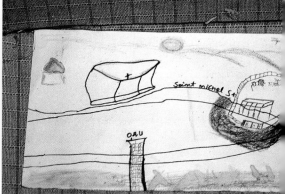

The wing of an angel

Tigistu was an enigmatic character who told what often sounded like tall stories. Stories about being a soccer star in Ethiopia, about singing on radio, about being part of a family that had suffered political persecution, and about a brave escape to Kenya on the day he wrote his final school exams. He said his father was on the run somewhere in Africa, and he would like to find him. On the inside of his suitcase, though, he drew a set of muted images of the home he had left behind in Ethiopia, and told a simple story of loss of childhood.

I have a baptism name like every child in Ethiopia. Mine is Knife. It means wing of an angel. When the priest blesses me, he always uses the name "Wing of an Angel".

I drew a picture of my house in my suitcase. This is my house, and this is the way to go in. It was a very big door. My father's name is written there on the door in our language.

I was having a small farm near where I used to stay in my house. This is where I used to play basketball and soccer. I had a basket ball

and a soccer ball. I think they are still inside our house, because our house is locked. Nobody is allowed to open it since we left it. Maybe I'll find my ball when I'm going back …

I used to play soccer and basketball with my friends – their names are here on my suitcase. We were in the same group; it's a soccer team. Next to the field was a house for a very, very old mama, and she don't like us to play in this field, because the ball would always enter her house. And every day when we play, the ball would go into her house, and she would not give it back. We used to disturb her every day, and the ball will enter her yard every five minutes, and then she must come out and give us the ball. So when we came here, she used to chase us away. So one day, we did make a plan. Every day at five o'clock we would go to play in the field. And she would wait for us. But that day we made a plan, and we said everyone must go on the top of the lemon tree that was next to her house. Now she

is expecting us on the field, but all of us, we were here in that tree, and she did not see us. And we took all the lemons and ran away – everybody with one lemon.

One day the old lady returned our ball, and we take it back thinking it is still okay, but we find it is not working. She put a hole in it. I was the naughty one – she talked to my father. "It is your son who is collecting these people and bringing them to play here." She used to swear us in Italian, but we don't understand!

Maybe she will remember me still, because I was the naughty one. I made her angry because I liked to play soccer. I had the plan. Maybe she is not there any more.

This is a street where all of us, eleven friends, used to meet. This is a shop, a tuckshop, and the owner of the shop knows us. We used to stand there and meet. Everybody knew that if I am not at home

I am at that shop waiting for friends. I also used to meet my friends at this park. There were nice flowers there and I used to go and give them water every day.

In my suitcase, too, I have put a letter. When I was in Grade 9, my girlfriend write for me a letter – this is my first time to fall in love, and that letter is in here in the envelope. It is my secret. I will show them at home one day when I am taking this suitcase back.

This is in my language. It is a sign in my suitcase, it says, "This is my clothes that I was wearing when I cross the border." I want them to be in also. I have them – they travel all over with me. I will put them inside. I want them to be in. I used to get angry where I used to stay, because they wanted to throw the clothes away. They said, "Hey these are dirty clothes!" Whatever, but those clothes have been travelling with me.

Give my suitcase to my sister

Soon after finishing his suitcase, Tigistu received a letter from his father, saying he was in Namibia. He decided to travel to Namibia to find him. He left one Wednesday morning, and never returned to the group or to Johannesburg. No one knows where he is now. I still have his suitcase. Maybe one day he will return and take it to his sister himself.

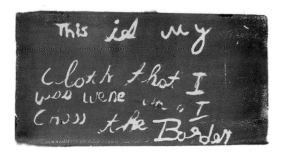

I want you to keep this suitcase, and if something happens to me, can you give it to my sister? My sister, she is a kind and nice, good woman. She is a girl, really, but nearly a woman. I left her at my friend's home. I have put a photo of her here in my suitcase. The suitcase shows when she was celebrating her seven-year birthday. We used to be at home together, and by that time my father was not there – that birthday we were celebrating without my father. It is me, the one organising the birthday, because my father is not there. She sent me a photo of that birthday. She wrote on the back of the photo, "I used to love this photo, but now you have it." My sister, she is a clever student at school, and she doesn't nag for new stuff. Other kids, they like everything that is new – she doesn't nag the family. When I leave home, I leave her with my friends. I have a trust for her, when she stays with my friends she knows she is a dependant on somebody, and she doesn't ask for things.

My father did write a letter for me. He wrote it from Namibia. He sent it to Ethiopia – he does not know I am here in South Africa. My friend sent it from Ethiopia to me. I can tell from the letter he is sick.

He does not know that my mother is dead. He says we must sell our house and come and get him. He does not know the government has our house. So I must go to Namibia to find him. Up to now I did not know where he was, even that he was alive. I am leaving on Wednesday.

It was my first time to see an escalator

One person who is still part of the group and who reminds us of Tigistu is Yeshak, his great friend. One day, Yeshak told me a little story about how he and Tigistu had met.

I came in a taxi from Swaziland and was dropped at Park Station. Now I was in Johannesburg. I did not know anyone. I had never seen such a big city. I did not speak any language except Amharic. While I was standing there, something happened that is amazing. I saw another boy my age at the station, and I could see he was from Ethiopia, too, by the way he looked. I went to him and greeted him, and he was Tigistu.

He walked with me to find somewhere to stay. I remember I was so amazed at that escalator at Park Station. It was my first time to see an escalator. I was standing at the bottom just looking up, and Tigistu was up

and was calling, calling, and I was just looking. People were bumping and pushing and even shouting at me to move, and I just looked at the escalator. Tigistu had to come down to get me.

He took me to some other Ethiopian people in Johannesburg, and I stayed there for a few days, and then he took me to Home Affairs so I could apply for asylum. We are friends now. I do not know if I have any family any more, so a friend like Tigistu is very important. I have tried to trace my mother and sister, and send messages back home with people who go there, but I do not know. I will not go back because there is nothing there for me any more. Where will I stay? How will I live without my mother?

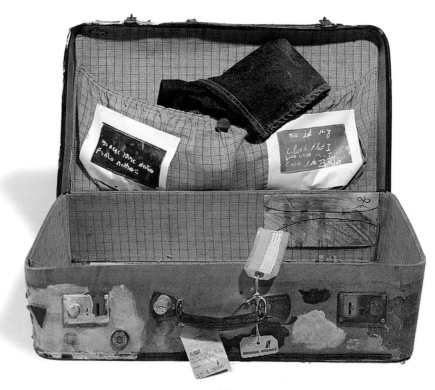

Refugees from Ethiopia

Ethiopia has a long history of conflict and displacement. In 1974 the monarchy was replaced by a military junta that continued to fight off bloody coup attempts, uprisings and wide-scale drought until it was toppled in 1991. During this period, tens of thousands of people fled the country due to political persecution, violence and famine. Some lived in refugee camps in Sudan and are slowly returning. The country is now formally democratic, but continues to spar with neighbouring Eritrea. The Ethio-Eritrean war began in May 1998 and displaced over 350 000 people along the common border, with another 95 000 Ethiopians being deported from Eritrea. Although the war with Eritrea appears to be over, the country is battling drought and poor prices for coffee, its major agricultural export. The government runs supposedly voluntary resettlement programmes within the country to help people avoid the risks of drought and famine, but there are regular reports that removals are forced, and that conditions in the resettlement areas offer no improvement. The government has also proved unwilling to tolerate dissent within the country, making it unattractive for return.

Esther's, Isabelle's and Beatrice's suitcases

When Esther, Isabelle and Beatrice joined the group they were seven, eight and ten years old. They lived with a guardian, and we were unsure about the whereabouts of their parents in the DRC. Their story is a story of finding and being reunited with their family. They now live with their mom and dad and three brothers in Yeoville.

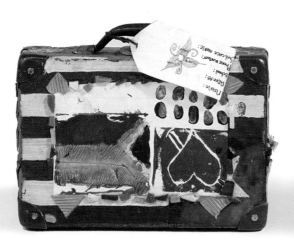
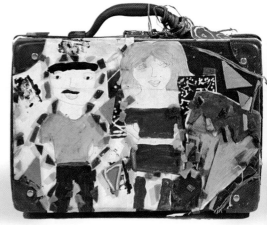

The birds were flying and singing

Esther, Isabelle and Beatrice were three beautiful little girls aged seven, eight and ten. They were always immaculately dressed, with shiny faces and braided hair. They worked with intensity on highly decorative, detailed little drawings. The outsides of their suitcases were dominated by drawings of their mother and father – a handsome father with a moustache, a beautiful mother and flowers. They carefully decorated them with tiles, beads and string. Diane kept saying, "I am sure their ancestors were artists; someone in their family was an artist." Yet we knew so little about where they had come from and why they were here. We knew they were alone, living with a guardian (Maria) in the JRS flat, and that their parents were somewhere in the Congo. Every time I saw them, I thought, their mother must be so sad not to be with them. Inside their suitcases they drew pictures of their childhood – dolls, birthday parties, a garden with a swing and their grandfather's village.

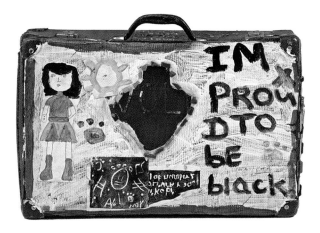

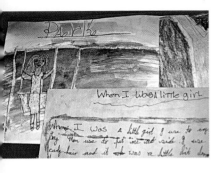

First my sister wrote my name – so if my suitcase gets lost, they can bring it to me. Then I just drew my favourite flower because I miss it. It was in my garden in Congo. This is my grandfather's house when I was six years old, and my dad and my mum, and here is me – and they are saying "Happy birthday."

I drew a picture of my mom. She's still in Congo with my three brothers. She is not with me. I think about her. She was a nice mum. Sweet. She cared about me, she loved me, she loved my family. She cooked for me, she buys me clothes sometimes. Even tells me stories.

This is me when I was small, and this is my roof and my house and my sisters, and this is the grass. This is me, and this is the avocado tree and the mango tree, the flower, the two birds and the dog. This is the house. This is a tin roof. I drew my dad. He has a moustache.

I drew my mum. I think about her, especially on family days. Family days are when it is time to spend time with your family. I think about her hair. Her hair is like mine. She makes a ponytail in her hair, and she puts clips and ribbons. When my sister does that style, I think about my mum.

This is on the verandah of my house in Congo. This is a plant in a pot, and the birds were flying and singing. This is the mango tree we had. This is my Lisa doll, my mother has her in Congo. These are my fingerprints, because maybe someday someone may steal my suitcase, and then they will check these fingerprints and see it is mine. These are stars and moons, because I remember when I used to watch the stars and moon at night. I was

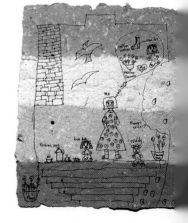

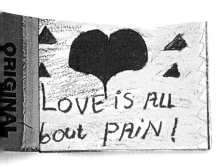

LOVE iS ALL bout PAIN !

in Namibia in 1999 with my uncle when I came from Congo. I was thinking and wondering and missing my family, and I wasn't with my family, I was with my uncle. I was sad.

This is me when I grow older. This shows me that I am proud to be black. This sun reminds me of Africa, especially Congo. This flower shows people I care about and love – especially my family and people who care about me – you, your family and Maria and my family. This is a butterfly. It reminds me of when I was small. I used to love butterflies and catch them. This is a heart to shows all the fathers are loved. I want to say to all the children in the world that they are special.

The footsteps of my grandfather

This is when we went to the village to visit our grandfather, and this is where he lived. He had a garden and a lemon tree and an avocado tree, and there was a nest in the avocado tree. There was also three houses, and he had a neighbour who always left his door open so that air can get inside. It was a real big house, and he loved living in the village, and this is his footsteps going to the market.

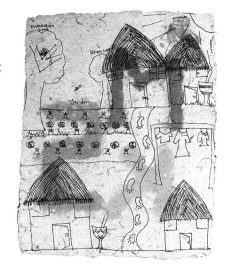

This is the thing that they put peanuts in, and they make peanut butter sometimes. I ate vegetables – carrot, cabbage and spinach – that he grew in the garden. He is going to the market to get coffee and when he got home

he made coffee. It was a Sunday, and it was never cold and it was always sunny. He always takes lemon and he put it in his tea. I called him grandpa – "Grandpère". He lived on his own because my grandma died. He died with this big avocado tree while he was cutting it. He died while we still lived in DRC. We never went back after he died. I think he is still here, though, in my picture.

The lion

Slowly we began to piece together their story. One Saturday Isabelle drew a lion in her journal. I asked her if she wanted me to write a story about it. This is what she asked me to write.

This is a lion getting out of the jungle and coming to the city. He is a big lion. He is coming to the city to eat people. He is like my uncle, bad. Trying to kill people and jealous of people. He will harm them and take their things. He wants things to be his.

Later, Esther told me the story of the cruel uncle.

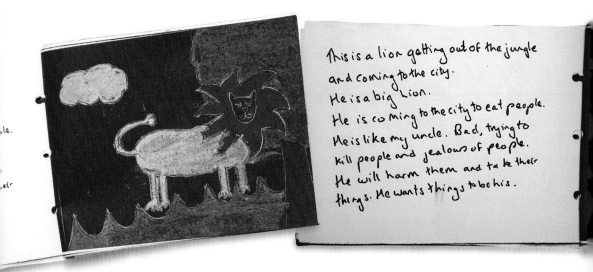

In Congo, my dad wanted all of us to come to South Africa. My dad was a lawyer, and then the presidents changed. And when the new one came they chased all the people who worked for him, and the new president put his people in. So we had nothing, and my dad thought we should come here. My dad's cousin was here in South Africa, so my dad said he could send us first, and send him money so we could stay with him. They were friends since childhood. So my dada sent us with another man to Lubumbashi, to Zambia, and then to Namibia, and from Namibia we came here.

So we ended up living with my dad's cousin, who we called our uncle. But it was very bad there. The uncle and his wife ended up saying we were witches and things. I told him I couldn't be a witch because I was little. We didn't go to school for two years. If his wife saw a cockroach they said it was my mother ... It was very bad. Then they sent us to his brother, to the same flats as the JRS shelter. The

brother used to hit us and didn't like us to go out, not even onto the balcony. One day he locked us out of the flat and Maria saw us. She asked questions and took us to JRS and told them about us. It was 2001.

Our parents did not know – they thought we were by our uncle's house. And when they phoned our uncle lied and said we were in school. And afterwards, my dad sent someone to see if we were okay. Someone at their church in DRC had gifts – she felt something was wrong. This pastor came to look for us and found us with Maria. Maria told them everything, and they told my mother and father, and they were crying.

Now we are still living with Maria and her family. If it wasn't for her, maybe we would be dead. Living at Maria's, it is difficult sometimes, sometime she doesn't have enough money to feed us all – we are a lot. But she tries, and now we are going to school.

I didn't believe

One Saturday the three arrived beaming. "Our dad is here!" Esther said, "He came to find us. He is living in Johannesburg now!" They then told me about meeting their dad after four years. As they told me the story, they all talked together, excitedly, repeating the phrase, "I just didn't believe!"

I didn't believe! I didn't recognise him because he became very thin. Even my mother was very fat. They got thin because they were worrying about us. We were … [*they all talk at once*] were watching TV and there was a knock, and Winnie went to open and she screamed, "Esther! Your father!" She recognised him because he looks like us. "Come see your father!" [*They still talk together*.] So she opened for him. Maria was by the bathroom washing the clothes, and she came.

We didn't know French, we had forgotten. And he didn't know English, only a bit. He just hugged us, and I didn't have anything to say because I didn't believe it – I thought it was my uncle transformed or something. I didn't believe it was him. We were in the room and he was talking with Maria and we were watching him – I just couldn't believe my eyes! I couldn't believe it – is this him or something? I didn't have much to say to him, because we could not speak French and he could not speak English. But I knew it was him because he looked like us.

I didn't say anything – I just told him what his cousin did to us. He was shocked, and sometimes he didn't want to listen because it hurt his heart, so he told us to just forget and to forgive him.

It is different from what we wished for

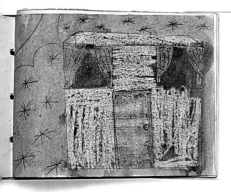

For some time after their father had come to Johannesburg the girls continued staying with their guardian. Then they moved into a room in a house with their father. The girls were more relaxed emotionally and obviously happy to be with their dad, but things were very difficult as their dad looked for work.

We were sad to leave Maria. At first we were very happy, because we thought we were going to live well. We have been to see her. She says she misses us.

At first I thought we were going to move and go to a nice house. I thought he had money with him. And then he told us all his money was gone, and they fired him from his work.

We first stayed with Maria because he was staying just in one room with other men. Then we moved with him to a house in Yeoville. We thought it was a nice house – it looked nice at night – but it had no electricity and no water. We used candles and sometimes we had to get water with bottles. At one stage we used to get only R10 a day. At that time we just had a packet of bread and

juice to add to water, and that was all. And we used to go school. We used to be hungry and all those things. Then my principal provided lunch, and he would come to our class and ask who did not have lunch. It is embarrassing when you were the only one, but we went anyway.

I forgot what she looked like

Two days after Christmas of 2004, I was at home with my family when my cell phone rang. It was Isabelle. "Our mum is here," she said immediately I answered, "and our brothers!" One by one the girls spoke to me, telling me their mum was with them. I arranged to meet them the next day, so they could introduce me to her. The girls were so excited for me to meet her. She was a small, thin woman who had the same beauty as her little girls. We hugged and she just held me for a long time. I felt the sadness of all those lost years, and wished I could just give them back to her.

As the girls say, things slowly improve. The girls have a mum to talk to about things, they work hard at school, they have got to know the two brothers they had forgotten and a third brother they had never met. Now we have six children

who produce beautiful decorative artwork, and it turns out Diane was right. Their mum is an artist!

I remembered her, my mum, she had long hair, but I forget what her face looked like. I just gave up hope that they would ever come. I just made myself forget about them once, because Maria said, "If your dad doesn't come and your mum, I will always look after you." But I remembered what they looked like, and I used to think about them when I am alone – and I would cry. But now they are both here.

It was on a Wednesday. We had to go to church. Esther had to go to the airport with my father and we had church – my father told us that our mother was coming. He told us that before. On the Saturday

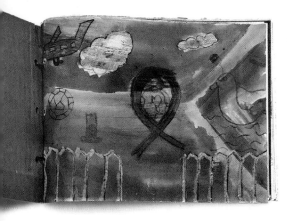

he told us, "Your mum is coming today." But the aeroplane was full so she couldn't come. So on the Wednesday he said she was coming, but we weren't really sure, because they had said it before and she didn't come. After we came back from church, we saw our mother and she hugged us. She was very thin, yooo! We were surprised, she was thin and darker. We were happy and surprised about the way she changed. She told us – eish! – She hugged us and she said, "You have grown so much!" and she cried. She told us she always prayed for us. She told us, "You see how God loves you? He has helped you."

It is different from what we wished for – we wished for her to come back and we would be in a new house, with furniture and everything. It is different but also good, because we don't really have to work so much. Before, when we came back from school we had to clean the house and wash the dishes, and we were getting low marks at school and everything. Now we clear the dishes, but

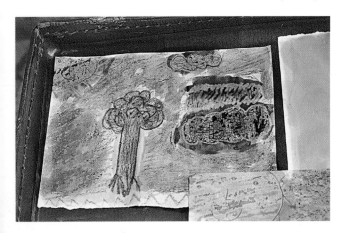

we also had to wash our clothes. Now we have our mum to help and to talk to! It's fine now, because we just felt bad always, because other children had their mum there to talk to and show her stuff, and we only had our dad – and before that we didn't even

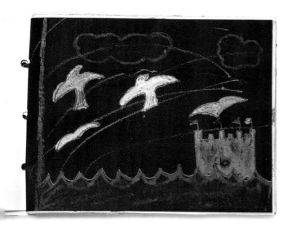

have our dad. At school they used to ask, "Where are your mum and dad?" Our classmates used to say, "Look what our mother bought for us." And they asked us, "What did your mother buy for you?" and we said we don't have a mother, and that made us feel sad and shy.

It is a big miracle that she is with us now. Mummy is glad to be here, because she is with her family and we are all together now. I only remembered Isaac and Ishmael –we didn't even know Jacques. When we saw our brothers I was surprised because they have grown so much. Isaac looks like Beatrice. People say that. I think we will move soon to another house.

Dad doesn't talk about what happened to us. My dad says just forget and forgive. With mum we talk. They blame themselves. She says she used to pray a lot and cry because she was worried. She felt bad, very bad. Only sometimes I feel angry. I just told them they shouldn't trust anyone.

The future should go in our book story. I think it will be much better than now. I think God will bless us, and the people who used to treat us badly will be surprised to see how we have grown up and what has changed. I think it will be much better than now, and I think my dad might get a job. There is money for food now. Our mum and dad are strong, and things go slowly, but they will get better.

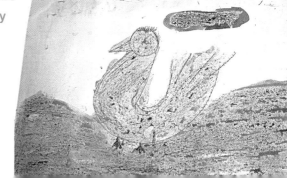

Roberto's Suitcase

Robert was 15 when he joined the group. He is one of the South African children who attends the Suitcase Project. He wanted to join the group so much he pretended he was from Mozambique, but soon confessed to being born in Kimberley. He lives with his mother and sister in Hillbrow.

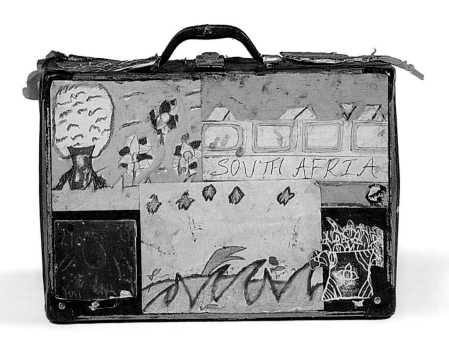

I want to be part of this group!

Roberto is a softly spoken boy who joined the group in 2003. He introduced himself as a Mozambican but after a few weeks confessed to being a South African. Once I had heard his story, I realised that he too was a migrant to the city, having grown up in Kimberley and moved to Hillbrow at 13, so I have placed his story in the book. He has become an integral part of the Suitcase group. Providing a gentle role model to the younger boys who follow him around, Roberto is the one who unfailingly helps Diane and me pack away at the end of the long Saturday sessions. He shows a protective concern towards Diane, helping her to carry the crates of materials, and carefully packing the artwork away in the back of her car, and warning her about driving around Hillbrow in her Venture. Once, while sitting talking under the tree, he told us why the Suitcase group has become so important to him.

Here in Hillbrow there are not many people who will tell you, "Hey this is beautiful," when you do something. But you guys do like our art honestly – you are not just saying it. It is worthwhile. I have never heard Diane telling us our images are ugly. It is always "beautiful!" [*He laughs.*] It makes you feel good.

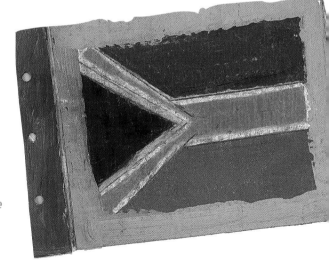

When we were looking at the stories in the book before publication, I asked him about why he had joined the group.

CJ told me about the group, but he said, "Hey, you know what? There is a bad part about this group." And I said, "What?" And he said, "We are all foreigners." And I decided I want to be part of this group! I want to stay in this group! So let me just say I am from Mozambique. I chose Mozambique because I just couldn't think of any other country, and if I said Angola, Acacio wouldn't believe me, and if I said DRC, Pasco wasn't going to believe me. So Mozambique just came to my mind.

Then when we were doing the artwork and I saw them doing their memories, I decided, "No, man. If I draw pictures of Mozambique I will be lying to myself, because I don't have any memories of Mozambique. So I just decided to say the truth, and if I get kicked out, I get kicked out! So I told you, and you just laughed and said that's okay. I think we had already got to know one another by then. I was actually surprised that you guys never threw me out. CJ was always telling me, "Hey, one day you're going to get thrown out of the group!" [*We laugh together at the memory.*] At that time Pasco never really knew where I came from, and I told him "Hey, I am not from Mozambique," and he said, "Ah, I kind of knew." CJ knew. CJ also played along – he introduced me to you.

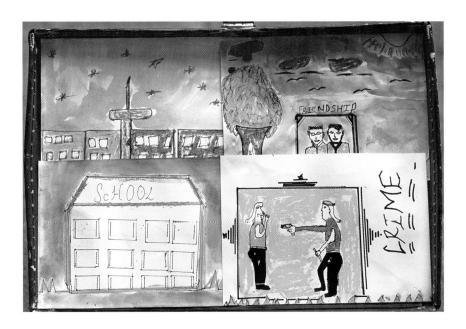

Things that people don't notice also happen here, like friendships …

Roberto loves Hillbrow even though he also fears the crime, and he sometimes thinks about going back to his childhood home, Kimberley. He sees the beauty in Hillbrow; the stars at night, the friendships he has made.

I drew the tower in Hillbrow on my suitcase, because it is something like the pride of Hillbrow, something that shows we are in Hillbrow now. My flat is quite close to the tower. From my flat I can see the tower, and it is very beautiful at night, and I always love looking at the stars, too.

Mostly at night is where people get robbed in Hillbrow, in the area close to the tower. They come to you, a few guys – one holds you from the back, one from the front. They search you, and before you know,

it is over, your cell phone is gone, your money is gone, your watch...

But Hillbrow is not only bad, because things that people don't notice also happen in Hillbrow, like friendships. This is where I met my friend Pasco. This is him here on my suitcase. He used to wear these big dark glasses. We met in a park close to Hillbrow. It has been damaged now, it is not there now. They broke it down to build something. It used to be a really nice park. Friendships were formed there, people got to know one another; it was like the main place of Hillbrow.

I still remember the day I met Pasco. It was a sunny day, as I drew it here. There was a clear sky. I was just hanging around the park and he was also hanging around there. We started playing basketball together, and afterwards we were so tired we just came here, laid under this tree and started speaking, getting to know one another. That is how our beautiful friendship started. I also met CJ again here in Hillbrow. I found he was living in the flat opposite him.

I was in Standard 5 when I came to Johannesburg. I was before that in Kimberley. It was a big shock to come to Hillbrow from Kimberley.

In Kimberley I was living with my mum, and she asked me if I wanted to move, and I said, "Ja, I want to go to Hillbrow, it sounds like a nice place." Because for people in Kimberley, Jo'burg is, like, wow! Big place, Jo'burg! It is the place to be! So when I had an opportunity to come here, I took it, and I never expected this!

Ja, it was something quite different from Kimberley. When I came here, I remember, everything was so big. The street lights – in Kimberley there are not a lot of street lights, and big trucks and big rubbish dumps. And the way people are too, it was very different, and it took me quite a while too to adapt into the lifestyle, slowly.

In Kimberley I was living with my mum, but in Kimberley it is funny, because you can live with everyone. I had a few aunties there, so

sometimes I would live with my mother and sometimes I would be in my aunt's house, and then the other aunt's house. Everyone was friendly to each other in Kimberley, so I was everywhere, sometimes with my mother, sometimes with my uncle, and if I am too lazy to go home, I just sleep over there.

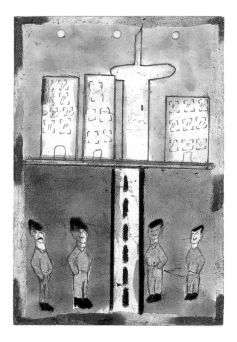

We lived on the edge of the town where there was a lot of animals. It was mostly cows and chickens. But there was a donkey, too, and I used to be afraid of donkeys and horses and stuff, and later on I even got to know a donkey. And one of my friends, she told me you know, donkeys are good, and I started to understand them. I even tried riding it once, and then I fell and decide no, no, no.

There are lot of animals in Kimberley, and every morning when you wake up there was roosters, and I used to get so angry. They say they wake you at 6 o'clock, but one near us used to wake at five, and I was so angry, I thought it must be drunk or something! There were a lot of fruit trees, but it was funny, as all the trees there used to be fenced, and we had to jump over the fence to get the fruit, and it was always a mission, because sometimes you would get chased. You would find a tree with nice apples and you want those apples, but you have to jump over the fence!

I had friends – not a lot – but I used to have friends. The bad part about Kimberley is that there are gangs – not heavy gangs – but there are gangs, and they try and be rough with knives and all those stuff, not guns. In Kimberley, the thing is knives. They like to stab

there. I think I may have escaped the gangs because I moved. I don't know if I was going to fall into those gangs, but maybe ... There was a cousin who joined, and he was always telling me, "Join, people will respect you more. Look at us, how we are, and look at you – you have no respect, man." That is the way it is in Kimberley.

There are lots of trees in Kimberley. So that is why I drew this river and trees. This is an image from my childhood. The river I still remember, and there used to be some nice animals here. There were frogs, and you would see them jumping around. I used to love going there. There is actually a myth about this river, that there were mermaids here. And my uncle told me that once he and his friends were coming here to catch fish, and it was really late, and they saw a mermaid sitting on this rock. And she was brushing her hair, and it was shining and it was all diamonds, and they were, like, just shocked, and they couldn't believe they were seeing a mermaid. And she just went back into the river, and the next morning they told us this is a magic river. I always wished to see that mermaid one day, but I never did ... We used to fish there and I never caught a fish. I always tried but I just never. My uncle, he also tried to teach me, but I never got the hang of it.

My mum thought at first it wasn't really that nice in Hillbrow. But then she met friends. I was the one who really had problems, and she was always giving me lectures every night about "Just be patient, things will come okay, you will see, just hang in there." And so I decided, okay. And at the end it worked out.

I joined the foreigner group

I also drew my school on my suitcase. It was a really nice school, but bad too in a way. There were some really nice teachers, but the children really took over the school. It had such a bad name that there was a school close to us, that when we walked past this other school, the children there just got embarrassed of us. Bad things happened there – smoking, drinking, no respect for teachers – and when I came in this school I was "Oh my goodness, I am probably going to go down too!" But fortunately I never went down. I stuck to what was important in life to me.

There were mostly black kids at KSS and a few Indian and Coloured kids, but they kept separate from the black kids and foreigner kids. I was with the black kids. Once we had a cultural day at our school, and I joined the foreigner group, and everyone was looking at me like "Huh, what's this guy doing?" And our show was the best when we had to act it out, and the school really noticed us then. Because they were just doing things and never took it serious, but our group, we were practising every day, and it was very nice. And from that day, I think they started noticing us.

CJ was at the school then too, and Pasco came quite late, so there were three friends at the school, and we stuck together. We made new friends also with the other foreigners. We kind of had a group. I fitted in with the foreigners because I didn't judge them, and most people in KSS judged them and thought they were better than them, and I took it that we are equal. I didn't mind if they are foreigners. I thought of them as just like I am, and that is why I fitted in with them quite well. My mother taught me to be like that. She was always telling me not to judge people and accept them as they are.

When I met CJ, we had a lot of things in common. We both liked

the same sport and stuff, and when he told me he wanted to be a doctor, it inspired me to tell him what I wanted to be. And then we met Pasco, who also wanted to be a doctor. I thought, these are all guys that have dreams, too, and we had other common things – we liked music – so I didn't really judge.

A lot of guys came to me at school, especially the Coloured guys, and said, "What's up with you? Are you stupid or something? Why don't you mix with us? Why do you always want to hang with those guys?" And at the end they even started not liking me any more. Eventually I wasn't even part of them. They just let me go, they wrote me off. A lot of guys even wanted to fight with me, and I just told them, I'm not going to fight with you. I also never fitted in with the Coloured guys. I never did all the stuff they did. They were always smoking, drinking, doing bad things, and I did not really like the things they were doing, always bunking classes. They fitted in with one another, they had the slang and I never had the slang, I never knew that "Howzit man?" and that stuff. It was really difficult for me to fit in with them, so I chose other friends.

Then I joined the group with the suitcases, and I was even more of a foreigner! [*He laughs*.]

I would love to learn how to surf one day

One Saturday, I ask Roberto what is it that keeps him from being like other boys in Hillbrow, and getting involved in crime.

There is a heavy pressure on us here in Hillbrow to get involved in crime, heavy pressure. I think it is the dreams we have that stop us.

Roberto has dreams – dreams that he describes with a quiet, lyrical longing.

Inside of my suitcase I drew two dolphins, because I just love dolphins. I know they are good animals and I would love to be free like dolphins – just jumping in and out.

I drew the sea on my suitcase. I love the ocean; it is very, very beautiful. I love looking at the stars and waves too. I love the waves. I would love to learn how to surf some day. And this is just some flowers. I like flowers a lot, so I drew them. I have noticed flowers make people happy, that is why I drew flowers. I also drew the environment because it is really important, and most people take it

for granted. Like in Hillbrow, they don't really care much about the environment. They would see flowers and just stamp on them, and cut the trees down just for fun, break branches and things. And I think that is very sad.

I would really love to travel one day. I hear people talking about our world – so many beautiful places out there – and I never get to see it for myself. And I just hear people say, this place is so beautiful, and this place ... It is my dream to fly, and I hope to reach it one day. I think flying has always been in me. From the first time I saw an aeroplane, I told myself I have to be there. When I was little in Kimberley, there was a place where they always used to land, and I used to go and look at them come down, but these were the small ones. When I came to Jo'burg and saw the big Boeing, I was like, "Wow! I have to fly one of those." I think I will have it in me forever to fly, maybe one day I will reach there. Sometimes CJ and them laugh at me when an aeroplane flies past. I go "Aaaah" and they are like, "Aaah." Sometimes I think I wish too much.

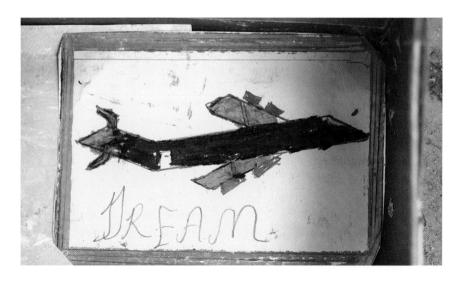

Acacio's suitcase

Acacio came to South Africa from Angola with his mother and baby sister when he was about nine years old. Leaving Acacio in the care of an elderly Angolan woman, his mother went back to Angola on business and never returned. Acacio has no contact with any family in Angola, and is estranged from his informal guardian and sister. He lives alone in the western suburbs of Johannesburg.

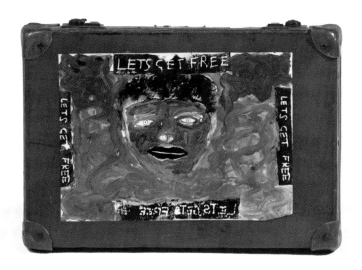

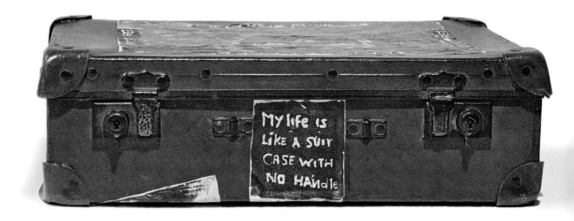

My life is like a suitcase with no handle

Out of all the children, Acacio was the most alone. He was 15 when I first met him. He lived in one of the JRS flats, but had not been placed under the guardianship of either of the women in the flats. He had no means of support, and, apart from the accommodation and school fees provided by JRS, had to fend for himself. He was a loner, used to using his charm to get food and support from kind adults. He seldom interacted with the other children, preferring to work and walk alone.

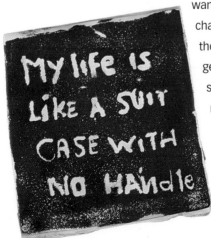

He did not sit for long at any one task, and spent the first few Saturdays wandering around, disturbing the other children and chatting to me and Diane. After two weeks of this, we thought it was time to encourage some work, so we gently challenged him to begin. "I don't know what I should do on this suitcase. There is nothing in my life, nothing to say," he said. "Well, maybe you should think about why you chose the only suitcase that had no handle?" He went off and made a simple print that he carefully glued on the suitcase where the handle had been.

Then he drew a sad self-portrait. I watched as he drew tears running down the cheeks of the face. When I looked again, the tears had been painted over. It was only later, as I got to know him better, that I realised how significant this was. Acacio seldom allowed any of us to see what he felt about being so alone. He preferred to play the "I don't care, I can cope, I am a survivor" game.

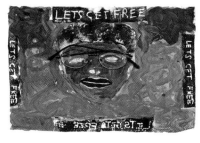

There are a lot of things going on around the person in my picture. There is blood and dark colours and yellow. There are good things and bad things going on around him – most of it is bad, like discrimination at school. The children we are schooling with, who are in the same class, they always gossip about you. "You should go back to your country!" Things like that. And they don't know we never chose to be here, it is because of certain reasons we are here, like war in our country. "Let's get free," it says on my suitcase. We are refugees in a foreign country, and the thing is, we want to be treated the same as South African people are. It makes no difference if we are not born here, because we are all African and we are all people. It is saying that refugees should be treated the same.

This sign here on my suitcase, "My life is like a suitcase with no handle," it tells more about the guy in the picture. The person on the suitcase, his life is not balanced, it is not straight. He is always falling and then needing to get up again. Like me.

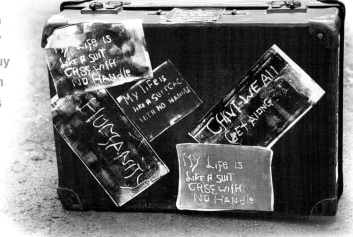

She went back and didn't return

For a long time that was all I knew about Acacio – his life was not straight and was out of balance, like his old suitcase with no handle. He talked little about himself, preferring to talk about refugees in general and life in Hillbrow, in his simulated "cool" American English, with all the hip hop attitudes and phrases. It was only after he had left the flat and was placed in a children's home outside Pretoria that he told me his story.

He had come to Johannesburg with his mother and baby sister at the age of nine. His mother had left them with an old Angolan lady in Yeoville (whom he calls his grandmother) while she returned to Angola – and never returned. As he grew older and more difficult, the old lady had sent him away, and forbidden him to see his younger sister. He seldom talked about his feelings and how being abandoned had made him feel, but often expressed the idea that he could survive because he knew how to get help. As he told the story, he was careful, each time he expressed any feelings of sadness, to add that he wasn't always sad, or that he survived anyway – never allowing any of us to see any weakness, or perhaps too afraid to allow his own sadness to come through.

Glynis uses Acacio's own words as fact not quote to describe his circumstance.

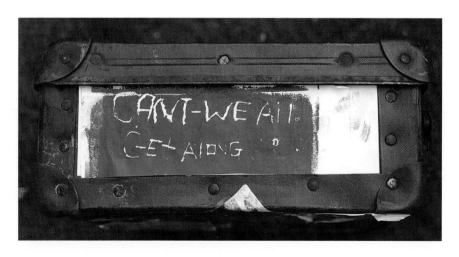

124

I ended up at the JRS flat. When I was staying with my grandmother we had conflicts and all that, so she chased me out of the house and I went to JRS, crying for help. Actually, I heard people speak about JRS and they reckoned it was a good place to get help, so I went to them and spoke to them. And within a week or so I was placed in the flat in Hillbrow.

It was me and John and CJ and the whole family. I was dependent on myself, though. They just gave me the room with CJ and John, no food. The way I survived, I actually just knew people who would help me out with money or something and sometimes get myself a pair of shoes, so I just survived on my own. I knew this lady at the Catholic Church, David my ex-school principal when I was in junior school and I was having lunch every Saturday at Art. I sometimes didn't have money for food. At times I would go next door to Brian's family. Their mom is really not very friendly, but sometimes I was so hungry I used to hang around at supper time, being polite and all, and she used to feel sorry for me and invite me in and dish up for me. But I was on my own, I was on my own. It builds some sort of character, I think.

I never felt sad at all, but I was also thinking of my mum, my mother. She was always on my mind. I was thinking of the way my mum took care of us, loved us and spoiled us. She loved us very much, she loved us. Although she is not around any more, she will always be my mum.

She went to Angola, but rumours said she is dead, so I really don't know. She went back and didn't return. She left me and my sister here with my Gran. She told me before she left she was going.

Actually, it's quite amazing, because every time she left I never cried. She was travelling a couple of times. The first time she left she came back; the second time she took quite a while. The third time, I cried. I don't know why I cried. I was surprised that this time I cried – I just had this feeling that I was never going to see my mum again. She never came back. This was 1996, and she left for good.

I wasn't actually feeling sad in the flat, though. I was a survivor – life is what you make of it.

It was cool in a way in the flat, and in a way not. I was feeling I am on my own, and I came home whenever I wanted and ate whatever I wanted, you know. I was feeling a bit independent like that. The disadvantages were that nobody would support me and that I was really suffering. There was this time – there were days – when I went to bed without anything to eat. I didn't feel bad that the other kids in the flat had food and did not share with me. I had a no-care attitude, and this is what I have survived on.

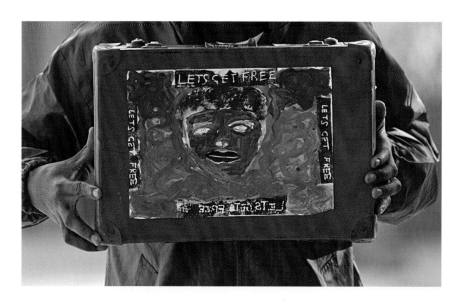

They were grown-ups in the cell and it was scary, scary!

When he joined the Suitcase Project at 15, he had recently been released from Lindela Detention Centre, where he had spent two weeks. This was the first of many spells in Lindela.

They came into the flat where we stay – the JRS flat. Actually, the police were asking us as we came into the flats, but I knew I had lost my papers, so I ignored them and went inside the flat. Then they followed us upstairs. Everyone was so scared. Zenash was there. She was so crazy mad with them, she screamed, and they tore her papers up but they did not arrest her. They took us, me and CJ. CJ's papers were locked in his mother's room and I had lost mine. They came into the flat, and that is against the law, isn't it? They came in and this police is asking for R20 and they will let us go, but we did not have R20.

They put us in a cell with 50 people. They were all grown-ups, and it was very scary, scary. We were treated like criminals. They made us stand up against the wall and they banged one man with his head against the wall. I was, like, praying. They asked CJ's mom for R1000 for both of us to let us out – R500 for me and R500 for CJ.

She paid for CJ. Then they let CJ out and they took me to Lindela. I knew CJ and the others were praying for me. I was going crazy, I was losing weight – I know I am thin anyway, but I got thinner. I was there for two weeks. It was such a mess.

I was really alone but I had my radio

In November of 2003, after the group had been meeting regularly every Saturday morning, news came that the two flats where most of the group lived were to be sold. Everyone would have to find their own accommodation. The two guardians made plans for their own children and those for whom they had formal responsibility. Zenash found a place to stay with two young Ethiopian women; Esther, Isabelle and Beatrice moved into a room with their father; Paul found a young Rwandan man to share a room with, but Acacio had nowhere to go. JRS had referred his case to the local government social worker. When I enquired what provision was being made for him at Social Services, I was told that his case was not their responsibility, as he was a foreigner. After many telephone calls between me, JRS and Social Services, a social worker did take some responsibility for his case. By this stage it was two days before the flat needed to be vacated, and he still had nowhere to go. On the Friday, the social worker sent him to a shelter for street boys in Hillbrow. He walked in, realised it was a shelter for children on the street, and left as soon as the social worker had left.

I was scared to stay there – they would have taken my stuff. I could not stay there. I just walked back to the flat, I had a key. No one was there, but it was better than that place.

He arrived at the group that Saturday with a large box of books that he could barely carry.

"These are my books that my old school principal gave me. Can you keep them until I know where I am going?" He then decided to spend the Saturday and Sunday night with the Catholic lady he knew. "If I just stand there, she will have to have me. Then on Monday I will go back to the social worker."

On the Monday, I managed to find him a place at a shelter in Benoni. I then left Johannesburg for the summer holidays, hoping he would still be in Benoni when I returned.

On my return I called the shelter, and was informed that he had been removed by Social Services, and taken to a children's home. No one knew where. His social worker had left government service, no one could find his file, and no one knew where he was. I was told again by one of the social workers I asked, "No, you must be mistaken, we would not place an Angolan boy. He is a foreigner, we don't deal with foreigners."

After a week I managed to trace him to a large children's home on the other side of Soshanguve, about 70 km from Johannesburg. Jessie and I visited Acacio a few times, both of us disturbed by the punitive nature of the home. It felt like a correctional facility. We could see that Acacio did not fit in there. He was the only boy who spoke English, and he was obviously experiencing bullying, but he never complained. He just kept telling us, "I am okay, I am a survivor." One Monday morning he phoned me from his social worker's office, and I could hear that something was wrong. He would not tell me, he just said, "I phoned to tell you I am okay. I am a survivor, aren't I? So I will be okay, right?" I guessed that he just needed to hear me repeat the idea and boost his courage. This is how he tells the story of his time with Social Services.

I was in the flat for a year. Then the flat had to be taken away, by December. So I had to leave the flat to a children's home. I didn't know where I was going. It was like living a life like I didn't know what was happening. I just never knew what was happening with my life.

We had to be out on the 28th November. On the 27th I still didn't know. I went to the social worker at government where JRS had sent me. I went to the office and I asked her, and she didn't have a clue where I was to go at all. She said the children's homes were fully booked, full! And she told me I should come tomorrow. She was always telling me that. I was feeling kind of scared, but on the other hand I was feeling not scared, because I got people who cared about me.

PEOPLE RUSHING FOR THE BUS

Then on the Friday when I came back, she sent me to the street kid home – yo! The assistant social worker took me. I didn't really like the place. I walked with the assistant social worker and I was like, "I don't think I will be able to make it here." It was very dark and the boys were strange – they were street kids. I just thought to myself, the flat was still empty for a few nights and I had the keys. I thought to myself, I am really not going to stay here. I went to the flat and slept the night there. I was the only person there, and I had the keys. I was really alone, but I had my radio, and the music helped me feel strong – and my books.

The next day I came and did some artwork, and then I went to the Catholic lady I knew, because they were to take the flat by the end of the week, and if I was there they would have evacuated me. I slept over for the weekend, and on Monday she dropped me at the social worker. You got me a place at Benoni.

The first time I came there I felt like a prisoner – I felt my dreams were shattered. I felt my life had ended. That is how I was feeling – I just couldn't see what is happening.

Before I left I spoke to you, and you said I was a likable person so I would not have problems. And that kind of encouraged me and gave me a bit of faith that I was going to be fine. And I survived. Then, after the holidays, they told me I didn't fit in their criteria – they said it was for street kids. And it didn't make sense to me – I am a kid with no parents and I had to leave the flat – if it wasn't for people and stuff I would have been on the street anyway. But whatever … Then the social worker fetched me in January and took me to Pretoria, Soshanguve.

I brought this vibe from Jozi

It was a long way, and on my way there I was thinking about my friends and my younger sister and Jozi [Johannesburg]. Jozi was like the place with my friends and everything I had and everybody. And leaving it was so hard. I was leaving to Pretoria. Finally I arrived there, at this far, faraway place, Soshanguve. As we were entering there it was like a location and that is where I went to. I had to stay there for a while, just to experience it. But I really didn't like it, it was very dull and boring and I felt there wasn't any hope for me any more. I was put in a dormitory with other kids. Most spoke Zulu and Sotho and not English. At times they felt inferior because I spoke English, but I was like, no, I just speak a language. It is just a language, and if I am speaking it better than you, that doesn't mean I am a better person. But they kind of like envied me in a way. But I survived, I survived that place. I made it. At times I was thinking of committing suicide,

but I made it.

Not much happened there – the only thing I had was my music. When I went there I brought this vibe "I am from Jozi," and then when my radio got broken they all vanished. One of them broke it because they were jealous. I wasn't feeling bad – I always had this don't-care attitude. I knew I had some people who cared about me, so I really didn't care about people who didn't want to be my friend. You were around and you visited me.

One Saturday I was sitting under the tree with the tape recorder and one of the other children, when Acacio loped in, greeting me with "Wass' up?" I thought he had run away and was already planning what to do next, when he told me he had been placed with an informal foster mother in Bez Valley, because he was now too old for the children's home.

How I ended up here, it was like this. They said I am 18 now, I am not supposed to be at the children's home.

When I first met you I didn't know my age – my Gran I lived with wasn't sure. I didn't have my birth certificate when my mum left. She didn't leave us with our ID documents and stuff, so I actually just never knew my age. At school I knew the date and month, but the year was a bit confusing. My mother left in '96 and I think I was around ten or twelve. So when I went to the children's home, I went to the surgeon. He said I was 18. Then they said I was too old for the children's home, and so my social worker made a plan and got

me a foster mum, and I was so relieved I was leaving there. And finally I made it and I left. I was so happy. My foster mum, shoo! I swear to you the honest truth – she is very demanding, she is very fussy – I know that is normal at times and I am surviving, but sometimes I don't really like what she says. She swears a lot and she gets cross – stressed out. She doesn't get any money for me – she takes her frustration out on us – "f" words and "b" words – and I am not comfortable with that. But it is better than the home, and I am surviving.

Someday I would like to go back home

Acacio continues to survive. He has left the foster mother, and lives off the generosity of others. At the end of 2004 he was again arrested and sent to Lindela. This time we feared deportation, as Angolans can no longer claim refugee status. Through the assistance of Lawyers for Human Rights he has applied for permanent

residence, on the basis that he has lived in South Africa for most of his life. But this process can take as long as two or three years. He has no contact with Angola, and is also struggling to gain an Angolan passport, as he cannot prove he is Angolan. He cannot get formal work, as no one is keen to employ a young man without papers. He is truly without identity, something that he expresses when he talks about his family and who he really is.

I think about my mom – we never actually got to know each other. I feel grown up now, and she was never there. I wanted to speak to somebody, somebody that would understand me, like my mum. But she is not there, she was never there. I have lost her. It is very sad. I feel like there is something missing in my life – my family, more especially. Things just never went well with my family. It is like we are all separated. In a way I need my family, but I can't reach them. It is painful.

When I was young, my mum, when she was still with me, told me that my dad gave me my name. He called me after his best friend. I don't know why I don't have an African name, but I have a Portuguese name. I was inquisitive where I come from, so I asked my mum once. She told me I have to follow my dad's culture. She told me what he was, but I have forgotten. It was long ago, when I was small and she was still with us, so there is a part of me I don't know about. My culture that I am living in now is unknown, it is just "Acacio living in South Africa meeting new people". My culture is unknown. It is just me adapting to what is there now.

Maybe I am too negligent now, and I don't even think about my culture. Maybe I have to find out. Because if I have to go back to Angola someday, they will ask me where I am from, and I will not know …

Someday I would like to go back home.

Background on Angola

Angola is slowly recovering from a 27-year civil war that ended in 2002, but its problems are far from over. The war killed an estimated 1.5 million people and displaced close to 4 million others within Angola and into neighbouring countries. Many who left Angola are now returning and close to 90 000 refugees were repatriated in 2004. Some are returning on their own, while many others are being transported back by international agencies as part of organised return programmes.

Much of the rural farmland is now filled with landmines, and little of the remaining arable land is available for those returning from long absences. Many who return from the region's refugee camps are therefore flooding into the cities, where there are already thousands of others, internally displaced persons also looking for work and protection. Despite considerable mineral resources, the government has proven unable to provide health, water, education or other material assistance for most of its citizens.

A large Angolan diaspora remains within southern Africa. Many who once held refugee status are now likely to be classed as illegal immigrants, and face harassment, detention and possible deportation. After a long absence from Angola, such a return only represents another displacement, especially for those born outside of Angola.

CJ's and John's suitcases

CJ and John are brothers from Burundi.
They joined the Suitcase Project when they were 12 and 15.
They came to South Africa with their mother
and young sister in 1993.

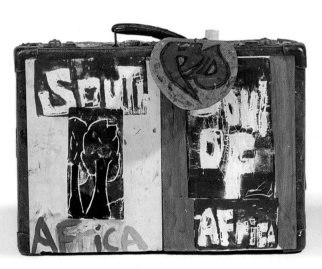
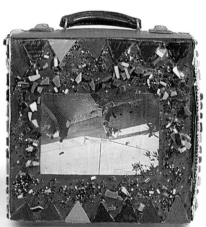

He taught me how to plant

CJ and John are brothers. They live with their mother and younger sister, and the children their mother has fostered. CJ is the older brother, a natural leader who has taken on the role of father in his home but retains a youthful sense of fun. He is everyone's friend. All the children in the group say they would go to him if they needed help. John was only 12 when I first met the children. He was a mischievous, sweet boy with a strong sense of humour. Since the group started he has grown so tall that Diane and I now have to look up to him. We are always marvelling at his growth, which he responds to with his shy, ironic smile. Both boys have a strong sense of purpose. They are disciplined about school work, look after their sister with care, and have a strong sense of responsibility towards their mother.

John placed a photograph of himself on the front of his suitcase, and numerous prints of a dog paw. At first Diane and I thought that many of the images the children drew, such as flowers and paw prints, were arbitrary. But we soon learned that everything had significance. John's paw print was no exception.

Assumptions made about children often wrong)

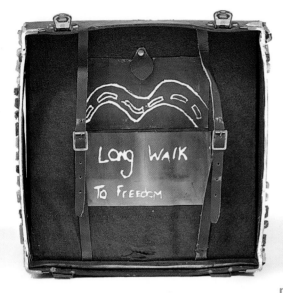

I put a photograph of me on the front of my suitcase. The photograph shows me. I was going somewhere, and the children in the flat next door called me and took my photo. I was not prepared for a photo; that is why I look so funny. I was going to a party for a friend of mine.

On the side of my suitcase I made a paw-print picture. We had a dog in the flat. They started complaining about it – the other people in the flats. We had to give it away. It was sad. It is like a person you get to know, and then you have to walk away.

We had to take the dog to Bertrams [a suburb]. We left it in the bush there. We left the dog there and we felt bad about it. We had to say goodbye.

Then guess what happened? After the holidays, on our way to school we walked past this house, and the dog was in the garden. It started barking, and we went to it to say hi, and the owner said, "Hey, what are you guys doing?" and we said, "We are just saying hi because it was our dog." The guy let the dog out and he jumped up at us. The man asked how much he must pay us for the dog and we said, "No, it is okay, you can have the dog." We were very relieved the dog did find a home. So this picture here is in memory of the dog.

Inside his journal John drew trees and vegetables – these too were part of his story.

I remember my grandfather used to plant in the garden. I used to help him work in the gardens. I called him Baba. He was my mother's father. He was a bit cheeky – he always told us what to do. But he used to like us a lot.

We lived at the restaurant. Every time when I came back from school, he would sit me down in the restaurant and give me food. Behind the restaurant was a small garden. That was where we used to plant the beans, cabbage. He taught me how to plant flowers. I used a hoe.

He showed me how to dig a hole, then put the seeds in, then close the hole, put a little bit more water. Then I came back after a week, put water again, put enough water to last the whole week. He is not still there. He died.

And here in South Africa we have a tree day at school. Each class plants a tree. That is when I remember my grandfather and his hoe and our garden.

Friday at three o'clock

John does not talk about why and how his family came to South Africa from Burundi. CJ's suitcase, however, tells more of the story – a story typical of so many refugee families – a long journey that does not always stop when the family arrives in the country of asylum. CJ has a vivid memory of the beginning of that journey.

The time the war started, it was Friday at three o'clock. I still remember the day. It was Friday at three o'clock, it was drizzling. I lived in a restaurant my mother owned – my grandfather left it to my mother because she was the oldest. Then the war started. It was very bad. People were still on the streets, some people had to run. Many people died, innocent people. Everybody died. This other small girl came inside our house to get away from the shooting, and started crying. She was coming from school. My mother told her to stay and go home next day. Next day it was like nothing happened, and we took the girl home.

But my mother decided to leave. Then my mum and me and John and Ada went to Tanzania. Ada was a baby. We were on a river – we went on a boat to Kigoma in Tanzania, and then we took a train to this other place. Then we went on a ship to Mozambique. It was a ship that transports goods. I only remember Maputo. We stayed there for a night by this other woman's house. Then we took bicycles, and we crossed the border. We paid those guys. John remembers it, even though he was very small. There is a jungle where there are animals, and we passed through that.

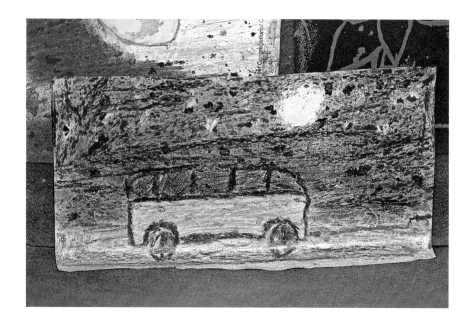

I was not too worried on the journey. It was a good thing, because it was a war in Burundi. The only thing I thought was there was war, and I never wanted to die, so for me it was from bad to good. I was going to a better place. The only thing I thought is, I am going to a better place.

Then we took a bakkie and then a bus, and my mother, I remember, did not have enough money to pay for me on the bus. They wanted to kick me out the bus, so everyone gave her the money for me. That is the only part I can remember of that journey. These people collected money for me. The rest I cannot remember. Then we stayed in a camp in Swaziland for a month or two – we learned English in that school at the camp. They supplied us with food and school. From Swaziland we went to Nelspruit. I remember we had to go to jail in Nelspruit, because we were the first Burundian people they had seen. I was five years old now. But they let us out.

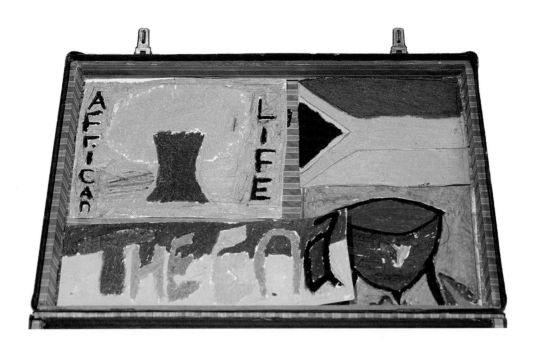

We had to go to these schools, but my mother did not like it, so we came to Bloemfontein in the Free State and we stayed there. We had to learn Sotho. They put me straight in Grade 3, and my mother was selling goods, and we were staying in a garage, and we went to this other white church where they supplied us with things. Then my mother wanted to move again. We came to Jo'burg with the train. At first we stayed in a shelter. And then we went to Mayfair and we stayed in this other man's place, in this small room – it could only fit one bed. There were six of us now, because she now had Jenny and Françoise. Then my mother worked selling things, and we got our own place and she had her own money. We moved in a place at the back of a Somalian's house. We moved into this garage – it was big. And then they came and broke in, and then she moved to Langlaagte, and then a friend took us to Berea, then to Troyeville. Then we went to the JRS flat.

I got up early to walk and look for a place to live

Both boys talk with affection about the JRS flat, where they lived in relative stability for a number of years, with other children who had been placed in the flat. At the end of 2003, the shelter was closed and the flats sold. John and CJ's mother had to find alternative accommodation for her children and the four children she was now fostering.

On one of the retreat camps with the children, we did an activity in which, using paper cut-outs, they described things, places or people they had lost. John cut out a picture of the JRS flat and lit a candle for the loss of this place. As he lit the candle, the group all began to reminisce about the place. In this place the children had created an alternative family, where they found support and an identity.

This was a house – it was the best house. It was like a hotel, the flat. Things happened in that flat. People say things will eventually come to an end, and it did, but before, we all lived there. It was a multicultural place, we were a family. We had trouble sometimes, but we *Franklin .* learned from our mistakes. Parties every day, boiling water at five o'clock [*the others laugh*], music playing. Not forgetting Esau [one of the guardians living in the flat]. He was my alarm clock [*everyone laughs*], praying at five o'clock in the morning. He was noisy, but he brought Christianity into the house.

Our lives changed from there when we all left the flat. We light a special candle for that house. Now we don't get to share time together like we used to do. Now it is that we are separated. I feel *UNHCR(* that I miss people sometimes, miss the crazy people around us. It was dangerous there but it was our home. Getting up early to boil water to wash. We lived like soldiers. I wear this chain here because I was in the army in this house. I survived.

For CJ the move from the flat represented a crisis. They had little money for rent. A family of eight now, his mother had gone to Tanzania to do business and had not returned as planned, so the responsibility of finding somewhere to stay fell on him.

It was hectic – there was a time when my mother did her business in another place and she was stuck and her visa was finished. Before she came back they told us we must go out of the flat. Mother had left some money, but not for rent or deposit. So we had no money, and we were so worried, and it was close to exams. JRS said they would only take people who didn't have parents, and they said they would leave me, John and Ada. And I became worried about where we were going to go. I could go to a friend's place, but what about John and Ada? I didn't know where to go. I totally gave up. I wanted you to take Ada and then I could find my own place. I became very worried. JRS came and said we have to move in two weeks' time. We found a place but they said there were too many of us. I got up early to look for flats every morning. I would look for "To Let" signs, and write the number, and come back later after school. I was worried about school because it was exams. Then we would go to see them later, and I hate that part when they say you are late by a day, come tomorrow, come tomorrow – but we knew we had to move out by the 28th. We then found that flat and I was so happy. I did well in the exams, but it was hectic, I was so worried.

They have roots in the soil of South Africa now

In spite of their difficult present lives, John and CJ are both positive about living in South Africa. CJ's suitcase has a beautiful printed image of a tree which sums up how he feels about his life here.

The picture on the outside of my suitcase shows how South Africa changed many refugees' lives. Some of us came here struggling, and it changed our life.

This picture that says "Soul of Africa" – the green part shows how refugees lost their land; the red is how we lost our families.

The yellow in the other picture is a bit brighter. It shows how refugees' lives changed in South Africa. They found people like JRS who helped them, and they were able to plant their trees again. The trees are growing together, and they have roots in the soil of South Africa now.

Pierre's suitcase

Pierre, who is 15, lives with his
young sister in a flat in Yeoville with
his uncle, aunt and three cousins.
They are all from the DRC.

My mother is missing

The group had been meeting for about two years when Pierre started to hang around. To begin with, he came in for twenty minutes, drew some pictures – usually with pencil or pencil crayon – and then disappeared, seldom staying for lunch. He obviously had artistic talent, but the drawings were disturbing – usually tortured faces. Diane praised his drawing, bringing him special high-quality crayons one week and special drawing paper the next. At first we were not even sure if he was a refugee, but after a few weeks he told us he was from the DRC and lived with his uncle. One Saturday he brought his younger sister. She was 11 years old, had huge sad eyes and said nothing.

We began working on body maps, and, to our delight, Pierre stayed long enough to let one of the other children draw around his body. Then he took the paper outside and worked alone under the tree. When he had finished, I asked if I could

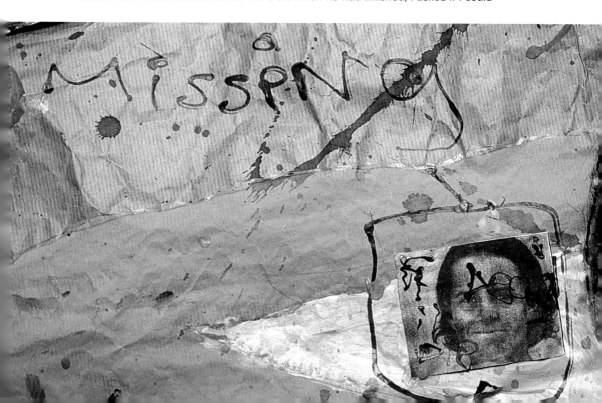

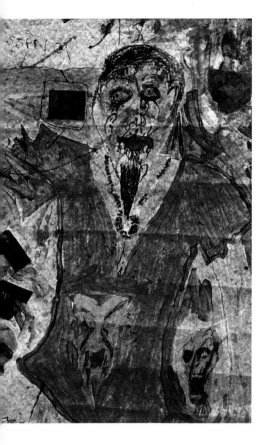

see what he had done. He had produced a shocking image of a corpse-like body covered in blood, but there was one image that stood out. He had cut out a photo of the face of a woman, and written "missing" across it. I asked if he wanted to tell me about what he had drawn, and he agreed. At first he struggled to say anything, until I asked about the face and word "missing".

This is on my resurrection. This is my future and present and …
 My mother passed away last year, and what I saw was quite scary. I am not sure, because I was at school, and the next thing I came home and she was dead. This is her – she is missing. My dad is overseas; he is from DRC. He is married to someone else. It is a sad picture.

He said no more, but when I asked when his mother had died he answered, "Two months ago." So I understood that much of what troubled him was grief for his mother. We continued to encourage him to draw. He and Diane developed a bond as she treated him like a fellow artist, bringing him good paper and encouraging his interest in drawing. He slowly began to relate to the other children in the group, began to stay to eat lunch, and brought his sister along more regularly.

 We brought in some old suitcases for the new children to work on. Pierre chose a very small, woman's vanity case. He meticulously covered it with beads in the colours of the South African flag, and drew his small, detailed pencil crayon drawings inside. One Saturday we sat under a tree, and he told me the story of his suitcase.

Then things got dark

This is where it all begins. This is a map of DRC. My parents were travelling; they went to DRC to meet my father's parents; my father came to South Africa and he met my mother here. This is when they arrived in DRC. My mother got pregnant, and she had to stay there for around nine months, and she gave birth to me. They had to return to South Africa and I had to stay with my grandparents for seven years. When I was little I spoke Chiluba, but I don't know any now – I just lost it when I came here. They lived in a place like a township. This shows how I was born, how I grew and grew and grew, and now I am like this. I was happy this side in DRC. I was living with my grandparents.

It was nice, but I can't remember a lot – it is a long time back. My granny and grandpa are still alive. They now live in Lubumbashi where they live with my aunt. My father built a house for them. I remember going to the farm to pick fruits, carrots – a big farm. It was a distance across the rivers. We travelled there for about an hour. We had to carry things back on our heads. They were nice people.

I was seven when I came here. Now I am 15. I came to live with my mum here in South Africa. Then things got dark. My father left us. He had to travel and go overseas, and he had to open his own business, and that stops him from coming home. He lives there now. He still calls and sends us money for support.

When I came here I forgot I was a foreigner. I just started speaking Zulu and being a South African. I did not know I was a foreigner. I remember people used to talk bad about foreigners, and I did not think anything about it. But then my mother told me I lived in DRC with my grandparents, I remember I was shocked, because I was now the person my friends talked about. But I got over it.

Borders mean nothing.
Franklin.

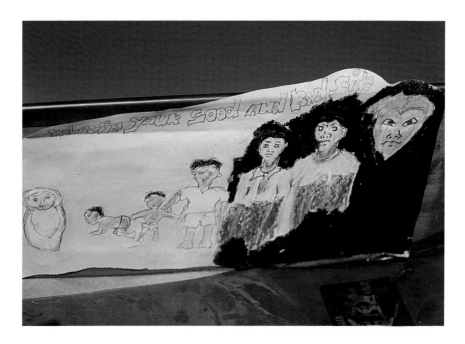

 All along my mother carried me like this, like she was carrying me on her back, until she passed away last year when I was in Grade 8. I have no idea what she died of. I came home one day and she was dead. And this is how my life changed from bad to good.

 I was forced to move with my uncle, my father's brother. My father sends support for me and my small sister. This is my uncle, the one I am living with now. I just tried making an image of him. This is me with a head and no body, because it is quite a hard situation – I don't feel that much in control. I am ruled by other people, being told what to do by my aunty. I like my uncle, but the rules are hard. My mum was better. She allowed us to do activities like going for camping, visiting some friends. I got a chance to chat to some other people. My uncle doesn't give us a chance to do any of those – just stay in the house, go to school and study, that is all. But he treats us all equal.

My uncle treats everyone equal. But when he is out, that is the main problem. His wife just treats us a bit different, and I feel bad about it. It is the same thing with my sister. I have never tried talking to her about how she feels – bad too, I know. She doesn't like it. [*He cries*.]

My aunt, she pretends when the husband is around. When the husband is not around, she changes. My uncle does not listen. Even when the uncle is around, he ask, "Is she lying?" When I tell him she is lying he gets angry and starts beating me. He is on his wife's side.

So now I just ignore her. Whatever she says I take as a joke. I only have one friend but he left the school. He had the same problem – just like me, exactly. His mother passed away. But he is not at the school any more. My father says we have to stay, we must just be patient because he will fetch us. My father got married again. He has one child.

You need a group for support

Before, I was on the street. I enjoyed hanging about with bad guys. My uncle did not see me that much. I would come home about 12 o'clock. When I moved in with my uncle, I started changing. My uncle helped me. He gave me the support. He also talked, he was great. What I am today is all because of him. This is also when I entered high school. I had bad friends in primary school. Then in 2005 was a new beginning – I made a New Year's resolution to study hard and put more effort to my studies.

This is where I just used to go. It is a night club where I used to go to take the stress out of me, instead of thinking what had happened at home. I have stopped now, but I used to run away from home

because my mum and dad were fighting on the phone, so I used to walk out and go on my own. This is the park, like a jungle. This park used to make me what I was, because this is where I learned to do naughty things, like smoking, carrying knives, practising all stuff. It was a gang. We had no name, just got together and began doing these stuffs. It was friends, we all grew up together. It was from 2000. I was still small, in primary. The other boys are still on the street. One is a street kid now – his parents chased him away. One is now a criminal; he was arrested, but he is out now, he is living nearby. And one is still hanging around in the park. Some, I have no idea; some I see at the shops.

It is like that for boys growing up in Hillbrow, you need to find a friend who you trust. You need a group for support – definitely. Everyone around here has a group. It is all about having friends, partnership and support. If you are on your own it is a big problem. If they strike you, no one to call.

So I had a group too. You know, you grow up together – my friends, we all met at the age of seven, Grade 1. We grew up, and we all swapped schools together. We started changing in our own way, to be cool, and we followed these adults, and we looked at copying them – people like 50 Cents, Jah Rule – the way they swear and look. So you become a gang and look like them. I have never stabbed someone, but I have been close to stabbing someone. Hatred is what makes you close to that. You have to get used to that. You have to

not be in fear – you have to be confident. That is how you survive in Hillbrow – you cannot show fear. You have to be confident whatever you see – look confident, walk forward. If you see criminals, just follow the same way as them.

But with a gang it is hard to quit the group. They will just agree as if in pretending, but on the following day you become their worst enemy, and they just beat you down. I showed my strength through fights. If you beat up the leader you can leave. I was able to leave because I was not that close to the group. They didn't let me go. They still see me on the street, but most of them I am not afraid of, so they leave me.

All of the boys in Hillbrow belong to groups. Some are good groups. For example, there is one good group, they are into hip hop but they don't do naughty stuff. I wish I could be part of that group. but I am not.

I like the art group here. For me, art is something interesting. It is the only talent I have got. In Grade 4 I started tracing colouring books and I realised this is my talent. I have creativity – I wish this would take me far. I am planning to talk to the school principal so we can open a small workshop on the school premises. I want to get a chance to exhibit my art. There is no art teacher at school. From Grade 10 we don't do art. Art means everything to me. If I don't succeed with other things, I know I will succeed with art.

The Suitcase Project

A reflection on the art-making process

Diane Welvering

Somehow, in order to make sense of this whole project, I have to begin before it all began as such. In about 1999, I was asked to facilitate the artwork that was to be part of a research/therapy exercise with boys from the Ekupholeni Mental Health Centre in Kathorus, Johannesburg. I was invited to do this purely on the

basis that I could work with children in a broad, creative way, using a variety of art materials; and, I suppose, because my end results were always exciting and different.

Well, that day I was scared stiff – I loaded the car with everything and anything that I could grab – I needed as many props as I could find to hide behind! Also I was convinced that it would all come in "useful". I knew that I would have to key in with the ideas of the resident psychologist, and my main objective was to avoid, at all costs, any atmosphere that might suggest to the children that I had a set expectation or prescription; a climate that would imply the levels of control and expectation found in a classroom situation. Ultimately, I wanted to

Process not Product driven.

create an environment in which the child participants could determine their own creative outcome, using their own initiative to the maximum. I wanted to provide a kind of creative free space, to encourage a spontaneous, extremely individual response from each child. I decided to offer the children such a wide range of art-making options that they could "lose

Unstructured

their own Voice.

get out of the way — natural expression

themselves" in the process. At an important point – where I felt creativity worked at its optimum – the children would no longer feel self-conscious, and would dialogue in close relation to the materials at hand, absorbed in the free-flowing dynamic of their own ideas.

I intentionally left "the teacher" back at home in Pretoria, because I knew that there was no space for her within this dynamic. I wanted, as far as possible, to blend in with the art materials themselves – lose my personhood, and just become part of the creative production mechanism. That day was a good day, a lucky day, where all things went the way they were supposed to – and I felt the power of what had been done.

try to eliminate power dynamic

As I sat in afterwards and listened to the children relate their powerful stories to the researcher and psychologist, I realised what an effective channel the art had created for them to talk about difficult things. The children at no time felt violated or exposed, and they had the power of choice to tell as much or as little of their stories as they wanted to. They felt in control, safely hidden within the artwork itself. In this exercise I saw the potential of giving these vulnerable children a sense of power and control – the ability to form their own narratives – even re-invent or re-interpret them later after the creative process had taken place. The created object, by its physical presence, allowed itself to become a sign of ideas formed at that particular point in time – the artist does not forget what he or she was thinking or feeling at that point. There remains the opportunity to re-interpret or investigate the text embodied in the object at a much later date – perhaps making more sense of it, or finding additional significance within the artwork. Nothing was cast in stone, and their own abilities to re-invent and re-determine their lives were assisted by this process. That day was one of the most powerful experiences of my life.

I met the Suitcase Project children for the first time during 2003, when I was asked by Glynis to facilitate the production of art that would help the children express aspects of their lives that were difficult to verbalise. After my first encounter with these children, I felt deeply moved and troubled about their situation, both past and present. As luck would have it, Joan Allison from the UNHCR expressed interest in the work we were doing with the children, and funded a ten-week programme, where she wanted a body of work from the group that would represent their lives, for presentation at a conference in Durban on World Refugee Day. For

[handwritten margin note: non threatening atmosphere.]

 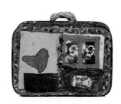 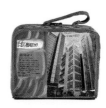 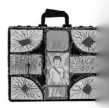

this purpose Glynis suggested the Suitcase Project, and I began to develop a creative-material system to support this idea. I soon realised how powerful the project was, and how much it was affecting the children. After the ten weeks had passed, I found myself unable to disengage from what had begun, and Glynis and I started developing the Suitcase Project and subsequent projects, not only as a means of telling the children's stories, but also as a means of reinforcing their life skills and reorientating them in the context of their individual situations.

Adult allies — intended to enable the process of empowerm

The open-ended approach toward art materials that I had used at Ekupholeni, coupled with the ideas supporting the initial ten-week project, has become an integral part of our whole working process. We encouraged the investigation of the following aspects:

- Memories of childhood
- Journey to South Africa
- Life in South Africa
- The future aspirations of each child.

The decision to produce this whole body of work in and around a set of old suitcases was most deliberate. We felt that these objects inherently signified many of the issues surrounding the lives of these children. At the time I considered the most obvious associations:

- The suitcases suggest a strong nostalgic element connected with past childhood memories; *— prompts self reflection — to incorporate past into present life*

- The used, worn state of the old suitcases could signify a parallel with the children's pasts that had impacted indelibly on their lives;

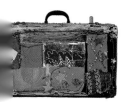 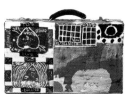 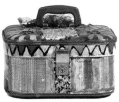 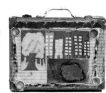

- The suitcase suggested the transient aspects of a refugee child's life;
- Inherent in the idea of "suitcase" is the promise of new horizons waiting to be sought out and discovered by its owner.

Suitcase is just a vehicle

We searched for old suitcases of every shape, form and description at second-hand shops. These suitcases made for a portable, easily packaged format for the art-making process in the field, and for future display and exhibition. Individual children were allowed to choose their own suitcase. They used the suitcase in an extremely flexible way. Individuals chose to display or conceal information in the suitcase at will. Some children took great pleasure in finding suitcases with a *establish* locking device, so that they could control access to the interior. *Sense of Control*

These suitcases functioned as practical metaphors for the reconstitution of the individual child's identity and life. They made excellent containers for the storage of work, and their three-dimensional character was used to the full, for the exploration of exciting tactile, visual and three-dimensional qualities.

These special objects became powerful, personal representations of the individuals who had made them. They embodied in their physical form all the things *Power/control* that the child had been denied. The very nature of their tragic life circumstances compromised all sense of who they were – their own personal histories were invalid within the South African context. They had become completely disenfranchised through their placement within South African society – they were "foreign" and "outsiders", and as such, did not have the right to own anything. They were left with none of the social privileges required to be able to develop a concrete sense of self. The individual suitcases became significant, not only as metaphors for their identities, but also as powerful representations of ownership – ownership of identity, ownership of physical space, ownership of something special and treasured – something they could take with them wherever they went; that they could manipulate and change and "grow"; a concrete place where they could leave a sign or trace of themselves; their own private place where they had the power to make a difference.

The suitcase also allowed the children to do their work over a long period of time – on it, in it and around it – allowing them to develop the multiple and meaningful layered character of the object, which made it a most effective therapeutic aid.

The use of the suitcase as a format was carefully considered. We started on the outside, asking children to represent their present lives – the point in the storytelling that would be least threatening. We also worked for some weeks on the development of the suitcases before any interviewing took place. Glynis would brief me clearly as to what part of the story she wanted me to encourage, and she would take some time at the beginning of each session to brief the children in a most subtle and open-ended way.

I think one of the reasons the project was so effective was that Glynis and I had clearly defined roles to play, which we never confused. I would discuss with Glynis

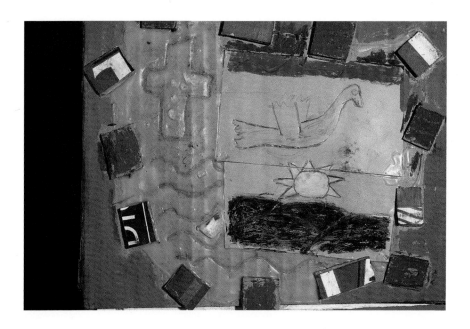

what portion of the overall project we were going to deal with for the next few

stimulate

weeks. Then I would provide multiple materials and techniques that I felt would
excite the children. Glynis orientated the children toward narrating aspects of
their stories – first the most non-threatening aspects, the present day, here and

Don't force narratives

now. We would never force the narratives, but would give the children absolute
free choice about what they wanted to say. We had many rather strange results
in the early days,– flowers, trees, birds, dog paw-prints, shoes from magazines,
women in fancy clothes – results we were pretty sure did not relate to the children's
reality … Later on, as Glynis began interviewing the children, we realised that all
these images had significance and linked with the children's lives – they never
just drew a pretty picture.

 I deliberately confined my role to that of art facilitation only. Obviously I did
observe certain aspects of behaviour related to the production of the art, but it
was never my primary focus. In fact, on busy days I would just keep the art

don't judge just keep flow going

production dynamic going, often quite oblivious of how much had been done. I would only realise the fruits of our endeavours when we finally packed up. I would dialogue openly and simply with the children as their work developed, never embellishing their stories for them, never assuming that I knew what was behind the drawing, nor expecting them to enlighten me. I would say things like "Those colours are exquisite," or "I like that texture there." Simple things, like "You are working well today," or "Wow, you are an art-making factory!" I left all judgemental or qualitative comments out of my dialogue. I never layered my interpretation onto their work, never made the children feel as if I was observing them – they get suspicious of that; it threatens them and they tend to clam up. Children who have been through what they have, have had more than their fair share of being observed, questioned and judged. The sensitive aspect of interviewing the children I left to Glynis. I was often totally unaware of each child's story. My main concern was to encourage the children to be confident in their ability to communicate

only
non judging -
Positive ,
non leading
feed back .

through their art. I never judged their ability to draw, and I responded to everything they produced, validating it as an effective means of communication. I never allowed them to throw away anything, and I was meticulous with the collection and packing up of all their work. By giving absolute value to each child's endeavours, I reinforced a sense of their own value. I consolidated a respect for each child's uniqueness and individuality.

There were several things that I considered when I worked with the children. I would make a very free creative space in which they could work – one central point where most of the materials were, then other areas which might get very dirty, such as printing areas. I would give them a lot of freedom with the materials, except if they were not concentrating and focused in their use of them. They often re-invented the purpose of the materials. For example, the wood glue became a staple ingredient for many creative purposes: children often coated objects with it, and then textured the glue or embedded objects in it. I did not mind

how much of a material was used, as long as it ended up being used productively on their artwork.

I would be meticulous at pack-up time, making sure that the children helped me clean the brushes properly and pack the things away in an orderly manner. I also did not tolerate the misuse or waste of resources. This served a function beyond just the preservation of the materials – it meant that they had to think beyond themselves and their own immediate needs. It encouraged in them a sense of nurturing, considering and caring – and a sense of preserving what you have for a tomorrow that is assured.

I found that when children were new to the group, they were often very greedy, taking much more than they needed for the task at hand, and often wasting what they had. They would also not be able to think of other children's needs. It was as if there was no tomorrow for them, and therefore no point in preserving the materials. At this point they would be more intent on what others were doing or

getting, rather than what they were producing, and the ability to look at what they were doing and focus one hundred percent was not evident. Some children were hardly able to produce anything at all, but spent their time interrupting the rest of the group. I left them alone and enthusiastically encouraged any meagre creative offering that they made – I never judged them or measured them up against other children's output. One thing I was absolutely rigid about was respect for other people's work – they were not allowed to interfere with the work of other children. Again, this had a dual function – in addition to the most obvious, it also reinforced a spirit of respect, and the acknowledgement of the value of one another within the group.

Working with a variety of art materials was a most important factor – some children related more easily to certain materials. Some children worked fast and others extremely slowly; some liked colour, while others preferred texture and boldly expressive marks. The main techniques I worked with were wax resist, simple relief-printing techniques and collage – using found images from magazines. The suitcases were enhanced with a wide array of tactile materials: bright beads, mosaic chips, string, cardboard, their own images and words were all explored. We also looked at pulp and paper making. Small journals for inside the suitcase were created, as well as objects in clay.

Some of the children were very insecure about generating their own imagery, feeling that it was out of their league – something they did not have the ability to do. I would encourage them as much as I could, valuing their every effort. Sometimes this would still not produce results. This was where working with collage and

found images became most useful. After incorporating collage into projects on some occasions, I realised how important it was as an art-making medium to some of the children, especially when they could not draw their experiences. Some children perpetually asked for the magazines, so they could find relevant imagery and incorporate it into their artwork. Once they had stuck down the images of their choice, I would then encourage them to work into and on top of them, personalising the images and making them their own. I soon realised that selection was very specific – relevant textual phrases had been chosen, and images with a direct bearing on their lives. From a creative point of view, I found that children often chose images with a specific kind of colour quality or feel to them. The images were thus filtered through the child's perception – making them a very individual and creative choice. When Glynis interviewed them, we discovered that these images were closely aligned to their life experiences, and made for an honest, direct mode of communication.

A reflection on the storytelling process

Glynis Clacherty

Soon after the group began meeting regularly, I reminded the group about Zenash's request to make a book of her story. I asked if they wanted to do that. Everyone agreed so I brought my tape recorder along every Saturday. I knew that compiling a book would be an important way of making them visible in a society where they had learned to remain largely invisible. I realised that a book would be an important way of building their sense of identity and self-worth. I was also aware that telling stories is thera-peutic. I had worked for a few years alongside a clinical psychologist who used a narrative therapy approach and knew that this was a powerful healing tool. So I encouraged storytelling as part of the process.

As they finished a body of artwork in their suitcases or on the maps, I invited them to bring the artwork with them and come and tell me their stories. We usually sat under a tree in the school courtyard while the group worked in the nearby art room. Sometimes they came in pairs or small groups (usually friendship groups), sometimes alone. When working in groups the others would listen quietly, witnessing the story. The choice to talk was theirs, and for a long time some of the children did not come forward and tell stories. One of the group has in fact never told her story. They often opted to talk to me alone, especially if the story was a painful one. I always gave them the choice

of switching off the tape recorder, but they very seldom asked for this. It was as if the act of recording gave the storytelling more weight.

The storytelling approach was rooted in the theory of narrative therapy expressed by Michael White,[1] one of the important theorists in this area.

He says that therapists should help people to tell "thick stories", and by creating an opportunity for them to tell and retell their stories, to see what knowledge and skills they possess. In the telling and retelling, people begin to see that what looked at first like a passive account of a traumatic event in which they were the victim, is in fact an account of how they used certain strategies for survival. Over time, the story becomes multi-storied, and is an account of survival as well as trauma.

The use of multiple layers in the artwork in the Suitcase Project is a concrete expression of this idea. Through the artwork, children were creating "thick stories", stories in which they were more than just "a refugee".

1 Epston, D and White, M (1990) *Narrative Means to Therapeutic Ends*. WW Norton. New York

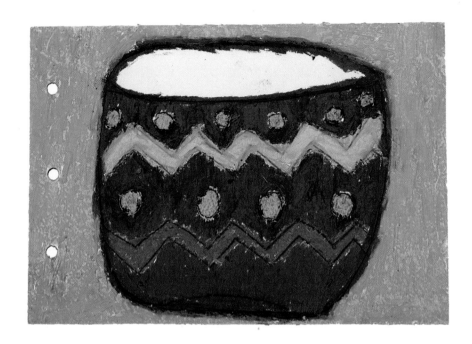

Through the storytelling about the artwork, they also began to see that their stories were full of knowledge and skills, and that they were not trapped and paralysed. This taking on of a "new story" is very evident in many of the stories contained in this book.

The children acknowledged the value of the storytelling as a healing thing.

It is a must to tell, because when a problem is in your heart there is no solution, and it makes you angry. But when you talk it makes you better.

For me it is, like, interesting doing all these things. I used to enjoy doing things like this. Memories of life, the workshop is about life stories. It is sometimes hard, our expression when we draw. When we draw, we don't just draw, we draw how we feel at the time. We express our feelings in the pictures.

> In the situation we are in here in South Africa, as foreigners, it
> is not like our country, but this reminds of us of our country,
> and helps us think back to the good things.

They saw that talking does help, but that it must come later, when they know the
person and when they can choose the time.

> When we talk about our mothers had passed away, it makes us
> sad. We need the time to be right to talk about those things.
> There are certain stories to be told and some not to be told.

> You work fine, because the secret you do is call us one by one,
> and that makes it easier. Some problems that some of us have,
> we don't want anyone to know. Also, you let us decide and
> choose to talk.

> It is good to give a person time, and sometimes when you remem-
> ber things bad, it is good to give a person chance before talking.

They valued the fact that they were never coerced into telling their stories. The
group attended a weekend with counsellors trained in a more traditional way of
working with trauma. This is what they had to say about this experience.

> When we told them something, they forced their way to ask
> about things we didn't want to say.

> This one time I felt sad, and this woman was pressurising me
> to talk, talk, talk, and I felt pressurised.

The avoidance of a trauma approach was a conscious one on my part. Much of
what I did was informed by the work of David Tolfree, who describes how, in the
past, most projects that gave psychosocial support to refugees were rooted in a
Post Traumatic Stress Disorder (PSTD)[2] paradigm. This approach uses a diagnostic

2 American Psychiatric Association (1980) *Diagnostic and Statistical Manual 111 (DSM 111)*

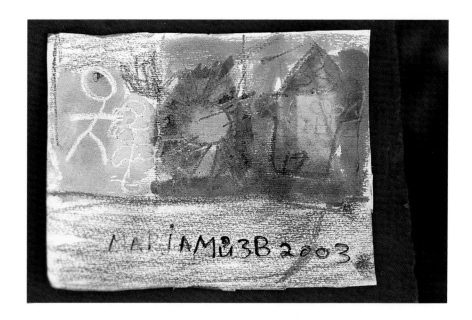

tool based largely on Western research in developed countries. The resulting counselling approach emphasises the need for victims of trauma to talk about their past experiences and express their feelings about it.

Tolfree outlines the criticisms of this approach. It is individualistic, does not take into account people's present belief systems and cultures, and looks at traumatic events in isolation from the broader context. It also tends to see the person suffering from PTSD as a victim, rather than as a person with resources, who, with support, can solve their own problems.

In his book of case studies, he describes a project that uses an alternative model for giving psychosocial support to refugees.[3]

3 In Tolfree, D (1996) *Restoring Playfulness: Different Approaches to Assisting Children Who are Psychologically Affected by War or Displacement*. Swedish Save the Children. Stockholm, p. 109.

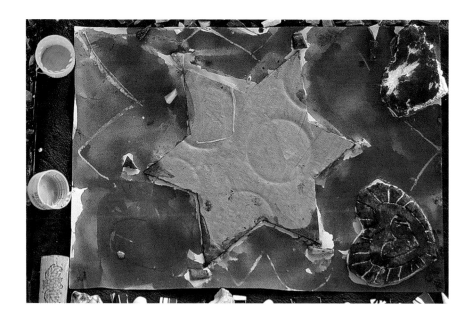

The model avoids the terminology of healing and therapy: rather the approach is firmly based on a developmental perspective which views human beings as having capacities and personal resources to identify issues they need to work on, and to deal with these themselves. By avoiding the typical stereotype of the refugee as helpless and passive … by avoiding terms which label people as traumatised or pathological, the [project] works with [the children's] strengths rather than their weaknesses. [4]

This is exactly what informs the Suitcase Project's approach. Tolfree's description of how the project works could be a description of the Suitcase Project.

The whole approach is based on the belief that all refugees are deeply affected by their experiences, but by avoiding labelling people as "traumatised" or as "having problems", the [project] is able to work in a way

4 Ibid, p. 119.

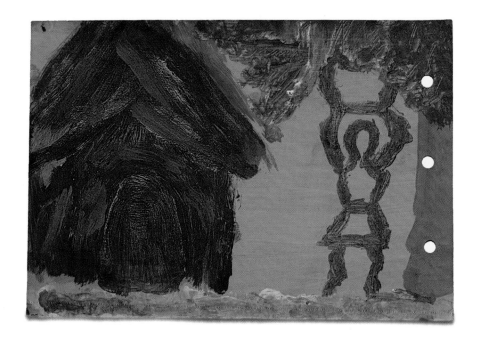

*that builds on people's strengths rather than weakness. No attempt is
made to "solve" problems or to suggest action which they can take. Rather
the aim is to provide a special form of interaction and the "tools" with which
people themselves can discover and build on their own and each other's
personal resources.*[5]

During the project the children's artwork was exhibited twice. Initially this was done
to raise awareness of the lives of refugee children, but ultimately it also served a
therapeutic purpose. The exhibitions became a way to integrate the children with
outsiders, and encourage them to be proud of their histories and home countries.
Over time, the group became very proud of their ability to do art. At the second
exhibition they freely opened up their suitcases and shared the contents with
academics at the University of the Witwatersrand who attended the exhibition.

5 Ibid, p. 113.

Over the time of the project a few journalists also wrote stories about the project, again making the children visible.

In all cases, the children were in control of the exhibitions and newspaper articles. They could choose to do them or not. They used this power too, informing a photographer from the *Sunday Times* that he could not photograph their faces. They were also involved in setting up the exhibitions. This reinforced the sense of power they had over their lives.

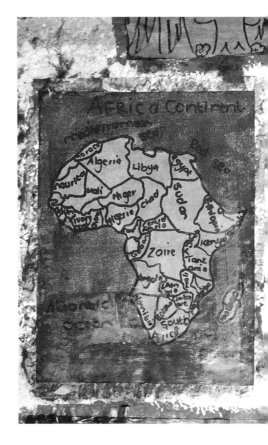

This public face of the project was very important for the children.

I think the exhibition was a cool thing to do, because it will make people know about what real foreigners are doing – most people just stay in their offices saying they are helping foreigners, without seeing the real lives of people.

We were celebs. It made me feel like a VIP, because the time we wanted to go into the art exhibition this man chased us away – he thought we are the street kids. Diane came and said we were the ARTISTS! I liked that. We were the ARTISTS!

I felt good that people were interested in our artwork and we were not wasting our time.

Meeting new people was the best. I met a young lady and her husband and she is an artist too. We met people outside Hillbrow world.

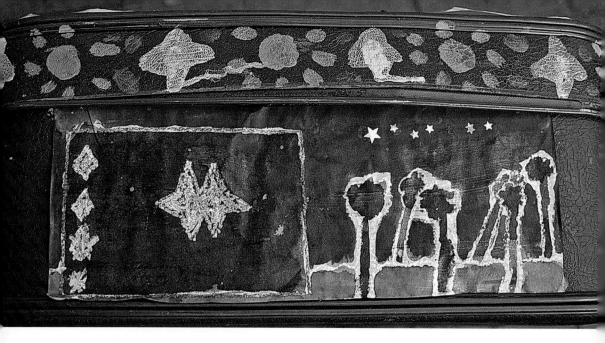

Encouragement of specific social interactions

Two levels of interaction were overtly encouraged in the project. Firstly, Diane and I encouraged them to build trust relationships with us. Many of the children had lost adult caregivers and had experienced deep grief, and were very wary of building relationships with adults, in case they were let down again.

In addition, many had also been let down repeatedly by adult service providers, who had promised them things and never kept their promises. Many also had stories to tell of how media professionals had exploited them. At least five of the children had stories of filmmakers or journalists who had promised them help if they told their stories. One journalist had even promised to take an Ethiopian child home to look for her parents. None of these people had kept their promises.

Understandably, the children were wary, and did not trust adults to do what they said they would do. Because of this, it was very important that Diane and I were consistent, and attended the meetings regularly. The meetings were held weekly so they could be a regular part of the children's lives, and we were very

careful not to make any promises about practical help that we could not deliver.

Every week we also asked about school, and kept track of particular events in the children's lives. Every week we asked questions about any child who was missing, and children who knew the missing child were told to pass on a message to say they had been missed. If a child did not attend for more than two weeks, home visits were made to find out why they were not attending.

Over time, the children began to reciprocate. They were very protective of me and Diane, making sure we did not go into dangerous parts of Hillbrow, helping voluntarily to clean up art equipment, and making cups of coffee when they thought we looked tired. This was part of the healing for the children; it allowed them to create caring relationships with adults, who, as far as possible, tried to be consistent in their attendance and give what care they could.

At the same time as encouraging relationships, this behaviour also modelled a set of consistent values that included, for example, respect for others and commitment to the group.

When asked why they kept coming to the group, children identified these relationships as an important factor in their continued attendance on a Saturday morning.

> You and Diane are here and you worry about us. We know you will help us with things. You are like a mother.

They also talked about how our responses to their artwork built their sense of self-worth and taught them valuable life lessons.

> – I have never heard Diane telling us our images are ugly. It is always "Beautiful!" [*Laughs*.] It makes you feel good.
> – Ja, There is no insultment here.

> You guys do like our art honestly – you are not just saying it. It is worthwhile. Here in Hillbrow there are not many people who will tell you, "Hey, this is beautiful," when you do something.

I have noticed in Hillbrow, people are all about making money – everyone for themselves. If you come with your art drawing and show someone and say, "How is this?" they will look at it for two seconds and say "Ja, whatever," and get on with what they want to do. But you really look and ask about it.

You teach us in the art to make something of our mistakes. We learn from the art that we can make mistakes and we can fix them. We can turn them into something good.

In addition, children could also articulate some of the values that were modelled.

Responsibility – to care for our own stuff. Because many people don't want to care for their stuff. Also, you taught us not to throw away our images, our art, whatever we do. Even if we think it is not beautiful, you say, "Keep it."

The second kind of social interaction that was encouraged was the attempt to help the children support each other. It soon became clear that in their everyday lives they were the best potential support for each other.

This was done through repeatedly encouraging respect for each other in the group. Everyone had to respect each other's artwork; no one was allowed to laugh at it. Group conflicts (which were frequent in the early days of the group) were handled firmly, using conflict-resolution and problem-solving strategies.

Over time, the group became almost an alternative family for most of the children.

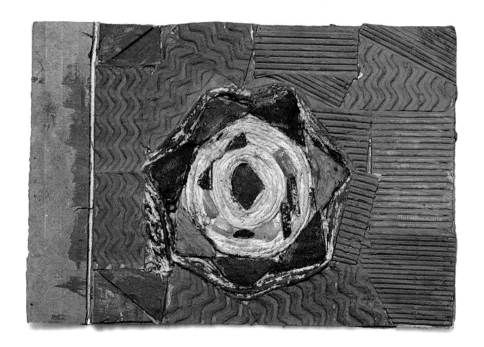

The art classes are not just for coming here and doing art. We are also coming here and getting to know each other. I never used to know John so much, but now I know him and he is like a brother to me, and I see him on the street and I feel good. We were next-door neighbours once but we didn't know each other, because the way Hillbrow is, everyone minds their own business. Now we are like brothers.

How much this was true became clear only when the two apartments that the children lived in were sold, and they had to move off to different areas of Hillbrow. Children showed fear at losing contact with each other at this stage. It was at this time, when their futures were uncertain, that the regular nature of the group and the consistency of relationship with the facilitators were particularly important to the children.

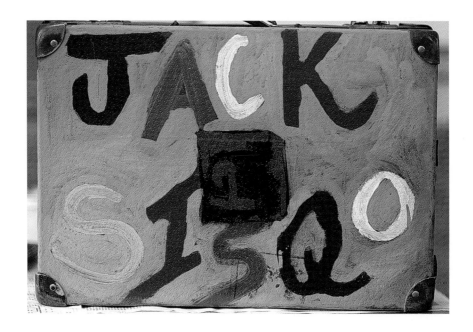

Linked to the idea of developing social interactions is the fact that the group took place in an informal space, and that children were able to come and go as they wished within this space. The workshops were open, in the sense that anyone could attend, and often children brought in friends – some who stayed for a few weeks and others who are still with the group. The art material was set up, and children came in to work throughout the morning. The only rule was that the children were expected to participate and to follow the rules of respect. At lunch time they usually sat on the grass outside, and talked and socialised in the sun. It was one place they could just relax in in Hillbrow. The children identified this relaxed space and the safe venue as a significant factor in their continued attendance and commitment to the group. The children also talked about how having the art workshops gave them something constructive to do on a Saturday.

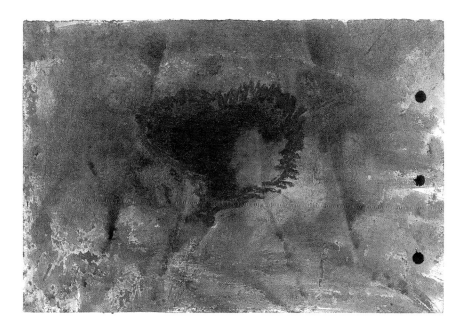

It is cool here. We can sit in the sun, we get lunch and we feel safe here. There is no place in Hillbrow to chill in the sun. The park is not safe, but here we are safe.

I come because it is fun, and you get to do different kinds of things. It is different from one's week with school and stuff. We come and talk about art. The art is fun. There is no pressure here like at school, with deadlines and stuff.

Usually every Saturday I don't have anything to do, so I come here. I would just stay at home or go somewhere not interesting. I also learn a lot about art, and I know skills I can use at school.

Attending these art classes keeps me from doing drugs and going around with knives. I met this guy Paul, and he told me to come here to do art. From then my behaviour started to improve.

I decided that I could use the art classes to improve my art. It gives me something else to do on Saturday, instead of doing bad things.

You don't get pressurised here to do something. It is fun.

In addition, the children were also encouraged to build relationships within the community. For example, a group of the older boys became involved in a local church that ran holiday workshops with children in Hillbrow.

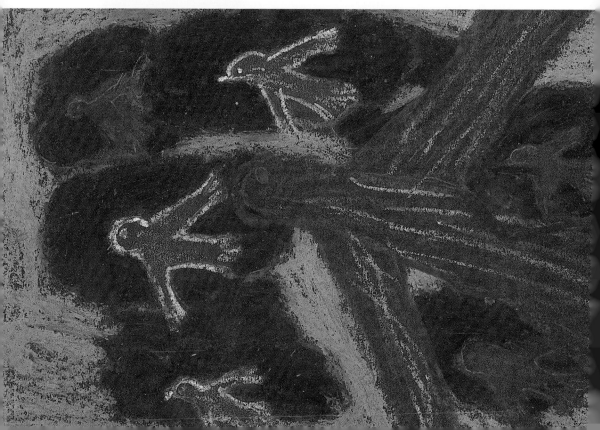

Where are you taking your suitcase?

Once the suitcases were finished, the children began to work on large maps, to tell the story of their journey to Johannesburg. They began by making large pieces of hand-made paper. They then made collages, using magazines and hand-drawn pictures.

The group then went on to work on large body drawings. They drew around their bodies, representing themselves with their suitcases, many making almost perfect replicas of their suitcases. On the body drawings they drew and painted and printed images that answer the question that was posed to them, "Where are you taking your suitcase?"

This work prompted the older members of the group to come up with concrete plans for their immediate futures. For example, two of the boys, who are over 18 and at present in Grade 9 and Grade 10 at a local high school, were concerned about the quality of education they were receiving. "I know I am not going to achieve my dreams if I stay in that school. Even the principal said to me I should find somewhere else." They had collected information about a local technical college, where they could do matric in two years and gain entrance to a Technikon. Reducing a year of schooling is very significant, given that they are both 18 already.

These were all children who were so paralysed by their past trauma when they joined the group that they could not even commit to coming to the next group meeting, never mind thinking about planning for their futures.

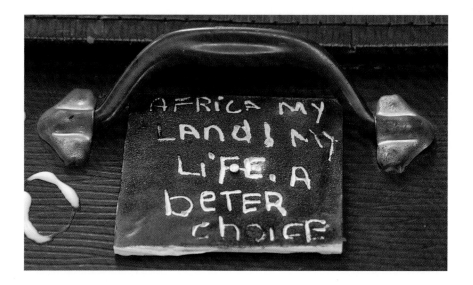

Where are the children now?

The older children in the initial group have begun to move on, though they all maintain some contact mostly through the once-a-term meetings that have replaced the weekly meetings.

Aggie has done a course in child care and is looking for a job in a crèche. She shares a room in Hillbrow with a friend. Her life is still precarious as she relies on the kindness of strangers, which is why a job is so important for her. Pasco is studying electrical engineering at a local technical school, and rents a room in an apartment in Hillbrow. He survives because he has a sponsor. Roberto attends the same school, also with a sponsor.

Paul is at school. He still struggles with remembering things but he is settled and happy at the school. He stays with other young people in a shelter run by the Jesuit Refugee Service. Jenny sells goods on the streets of Rustenburg, a small town about two hours' drive from Johannesburg. She makes enough money to pay rent and buy food, but she struggles to find the money to send Jacob to crèche.

CJ, John and Françoise were all attending the same school and were accepted into the school hostel, but before the school year began their mother (and foster mother) took them away. No one is quite sure where they have gone, though rumours include Dar es Salaam. We all miss them. Acacio struggles. He has no identity document, so has not been able to get a formal job. He is trying to start a small business hawking goods on the street, and hopes to make enough money to pay rent in a room where he stays with a fellow Angolan. Pierre continues to live with his uncle.

A group of new children has recently been referred by the Jesuit Refugee Service and the Refugee Ministries Centre, and they have already begun work on their suitcases. But before the initial group disperses, they will be involved in the writing, production and publicising of this book, which is a further step in the idea of making them visible to the world.

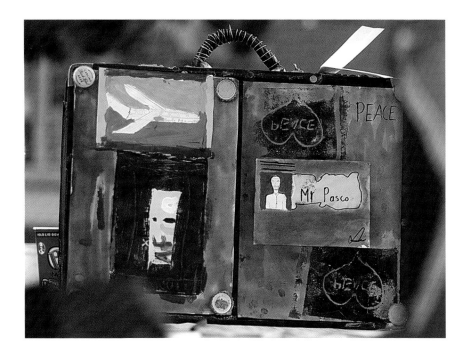

Tell Zenash I am waiting to put her story in the book

So why is Zenash's suitcase and story not here? What happened to her is an example of the risk that faces all these children if they are not given enough support.

Her fierce, independent spirit, the spirit that had allowed her to survive her epic journey, soon came into conflict with the woman who was her informal foster mother. She left the shelter. I continued to have contact with her, fetching her every Saturday from the back room where she slept on a mattress on the floor with three other young Ethiopian women. School had become frustrating, as she was placed in a class of children much younger than her because her English was not good. For a while she attended a Skills college, but she became depressed, and needed, like many teenage girls do, the ongoing unconditional support of a parent. She disappeared. She did not return to the school to write her exams, and no one knew where she was. The social worker at JRS recorded a missing person docket, but who cared to find a young foreigner?

One day she phoned me. She said she was okay, but it was not good where she was and she needed help. I arranged to meet her in town, but she did not arrive. I continued to leave messages on the different cell phone numbers I had. I always said "I won't be cross; I am not going to judge anything you have done – just come and talk to me and let me make sure you are safe."

One Saturday Aggie said she had seen her, and she was living with a boyfriend, an older man, and it was not good. But Aggie would not tell me where she was. I sent another message. "Tell Zenash we are writing our book and we need her story in it."

When Aggie went to find her, she had moved away …